ABANDONED
OHIO

ABANDONED OHIO

Ghost Towns, Cemeteries, Schools, and More

GLENN MORRIS

America Through Time is an imprint of Fonthill Media LLC
www.through-time.com
office@through-time.com

Published by Arcadia Publishing by arrangement with Fonthill Media LLC
For all general information, please contact Arcadia Publishing:
Telephone: 843-853-2070
Fax: 843-853-0044
E-mail: sales@arcadiapublishing.com
For customer service and orders:
Toll-Free 1-888-313-2665

www.arcadiapublishing.com

First published 2018

Copyright © Glenn Morris 2018

ISBN 978-1-63499-061-5

All rights reserved. No part of this publication may be reproduced, stored in a retrieval system or transmitted in any form or by any means, electronic, mechanical, photocopying, recording or otherwise, without prior permission in writing from Fonthill Media LLC

Typeset in Trade Gothic 10pt on 15pt
Printed and bound in England

INTRODUCTION

Ohio became a state in 1803 during uncertain times between the Revolutionary War and the War of 1812. Westward expansion of the United States depended on its success, and Ohio's pioneers were determined to help make the country stable and continue its growth. Thousands of towns were founded in the state through the canal days of the early 1800s and the railroad boom of the mid to late 1800s. This book is the culmination of six years of researching and exploring Ohio and its history, both the successes and failures.

Abandoned locations can be found in every county and almost all towns have at least a little bit of a ghost town within them. Businesses and towns, of course, can fail for many reasons. Sometimes they simply weren't a good idea and never had a chance to begin with. Most rode their success as far as they could and faded out of existence. In any case, every abandoned location in Ohio has some form of historical significance which deserves appreciation and documentation.

Residential buildings also have similar requirements as towns and businesses to remain useful and occupied. They need an income and someone who cares enough to keep them maintained. Wherever abandoned towns and businesses are found, abandoned houses normally accompany them. Researching former land owners and learning about their genealogy greatly enhances the experience and fun of actively exploring abandoned places. It can be done prior to going out exploring or after unexpectedly encountering a location that wasn't on a planned list.

The towns in this book are classified into four categories: ghost, semi-ghost, small, and historic towns. Ghost towns are usually completely abandoned by their former residents. Some lost their status as a town without ever being abandoned and have newer residences in an area that now goes by a different name. Semi-ghost towns lost a major percentage of their peak population, have multiple abandoned buildings, and may be in danger of becoming a ghost town in the future. Small towns average under 1,000 citizens, don't

have a lot of abandoned buildings, and most still have a post office. Historic towns can vastly range in population, from small towns to large cities, and have a requirement of numerous historical markers in the vicinity to be classified as such.

From one-room schoolhouses and iron furnaces to water powered mills and abandoned town halls, this book is an impressive source of historical and modern information. GPS coordinates have been added to the picture captions to aid in planning trips and conducting research. Panning around the area on satellite maps, both in bird's-eye view and street view, gives a better understanding of what to look for while on the road or when getting out the hiking stick to explore on foot.

The term "remnants" is often used in this book and refers to any sort of building, structure, or object that might be found while exploring an abandoned location. For anyone new to the subject, it helps to know what to look for, whether going on a planned or spontaneous trip. Training the brain and eyes to an explorer's perspective can take time, but once accomplished, you never look at the landscape quite the same again. Wonders of empty buildings, closed roads and abandoned bridges, rubble from fallen structures, and the occasional set of steps that don't go anywhere anymore fill the mind with inquisitive interest.

Glenn Morris
Ohio Ghost Town Exploration Co.

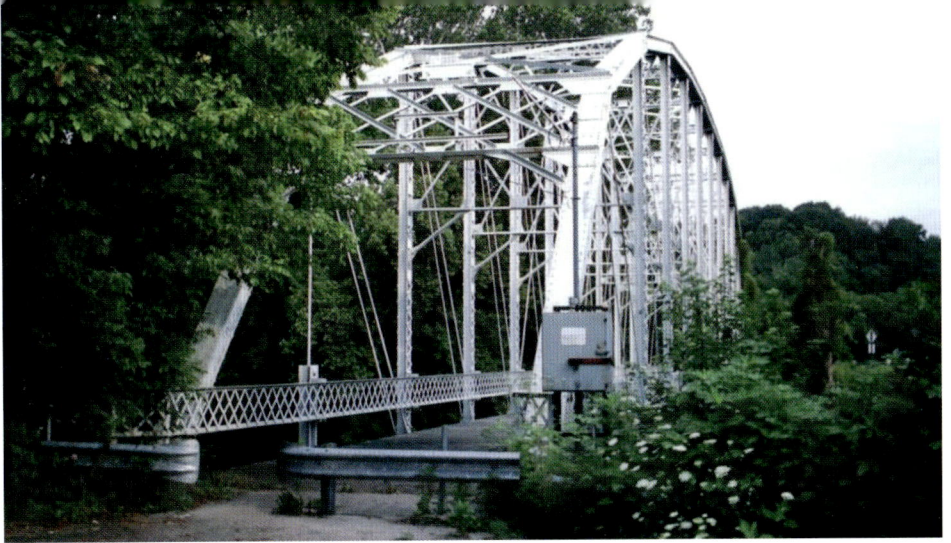

Cedar Mills Bridge, GPS Coordinates: 38.803409 -83.421010

CEDAR MILLS, OHIO (ADAMS COUNTY) — CLASSIFICATION: SMALL TOWN
Cedar Mills was originally called Brush Creek and became the site of the first iron furnace in the state which was constructed along Cedar Creek in 1811. Its companion iron forge sat on nearby Brush Creek. The closed road bridge, located next to a more modern section of State Route 348, was built in 1924 by the Champion Bridge Company of Wilmington, Ohio and crosses Brush Creek close to where the forge was.

The town changed its name after iron production in the area drastically slowed down in the late 1830s due to a declining iron supply. Mills became the main industry in mid to late 1800s. While walking across the bridge, one can imagine just a single car or small truck being able to cross at any given time back in its day and it simply couldn't handle the size of vehicles as they got larger over the passing decades of the 1900s.

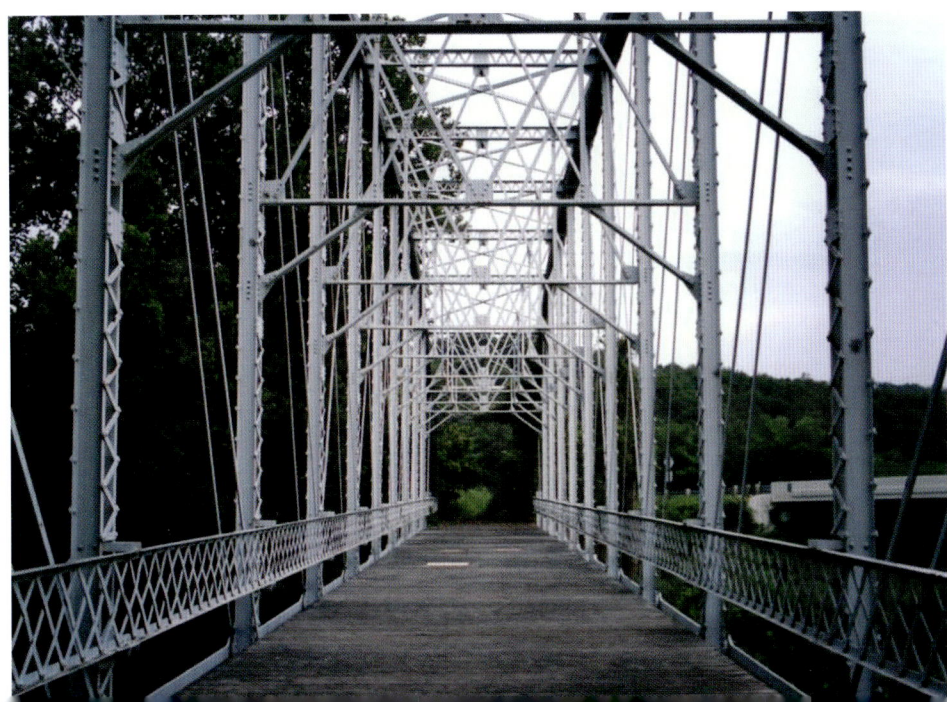

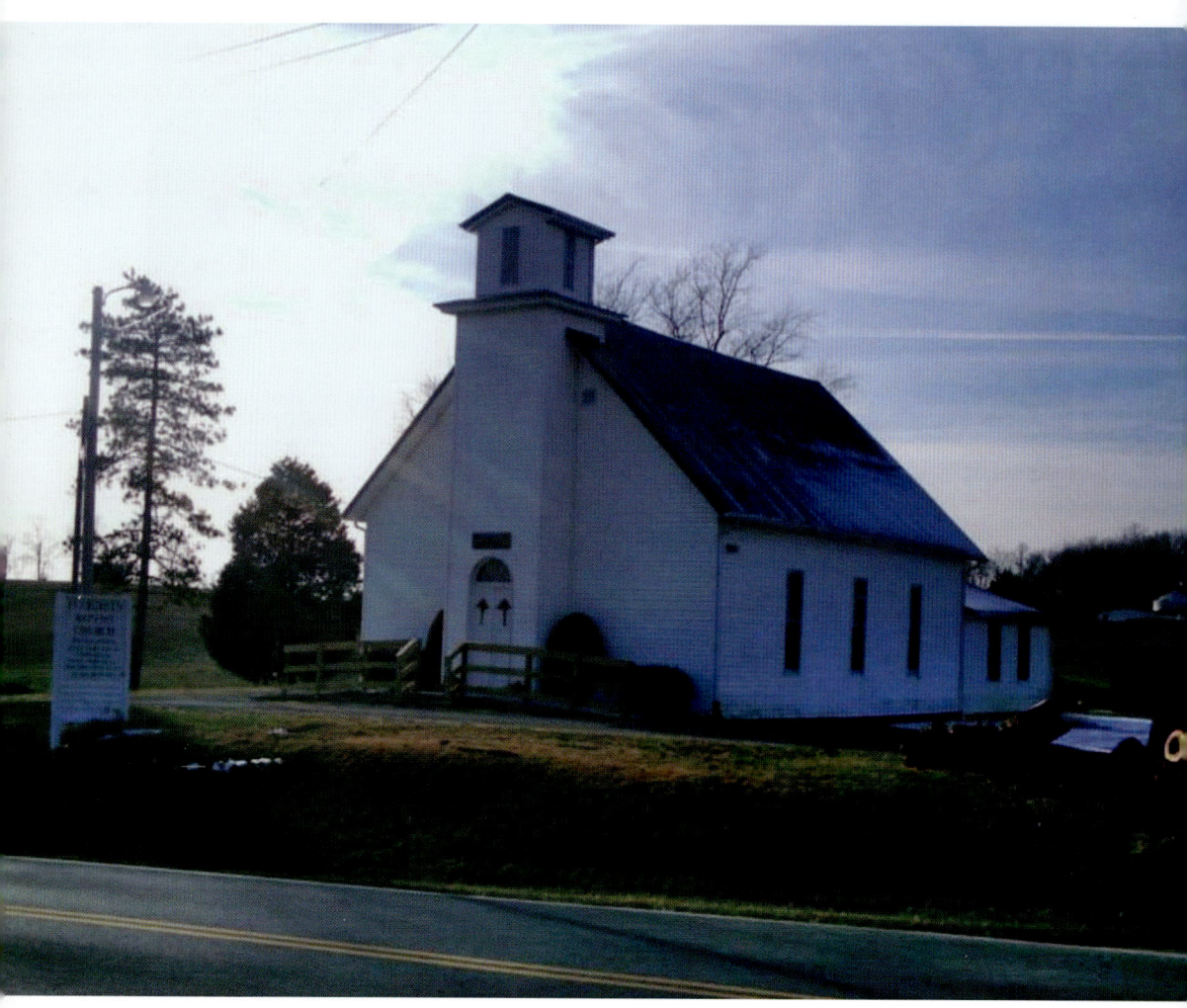

Evergreen Baptist Church, GPS Coordinates: 38.919176 -83.402640

EVERGREEN, OHIO (ADAMS COUNTY) — CLASSIFICATION: GHOST TOWN
Evergreen Baptist Church on Steam Furnace Road is the last public building left from the former town of Evergreen whose main industries were farming and raising livestock. It still stands proudly and quietly overlooking the countryside and some early residents were buried in the cemetery across the street from the church. Evergreen was never completely abandoned but is now considered to be in the unincorporated community of Steam Furnace.

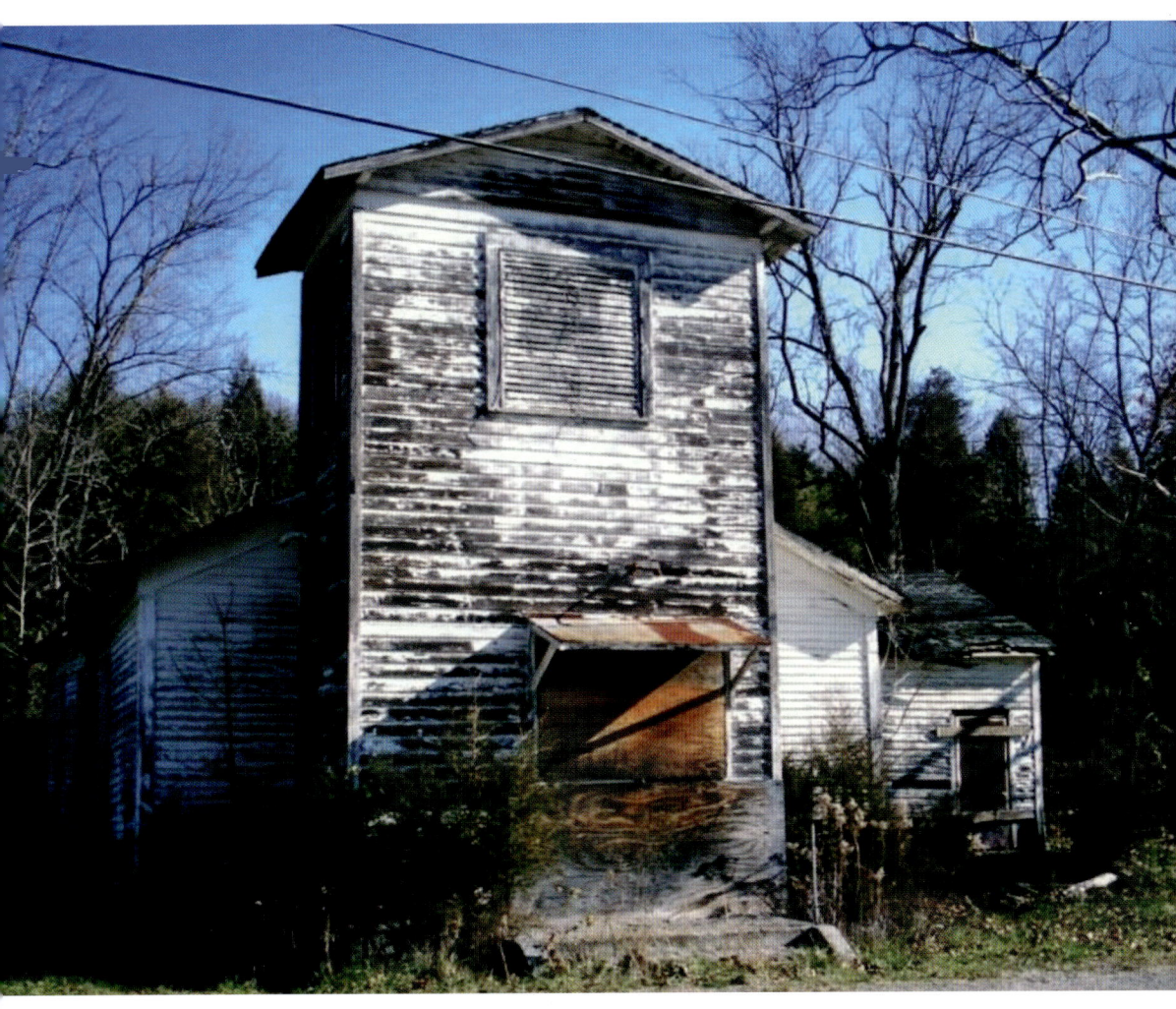

Steam Furnace Turkey Creek Church, GPS Coordinates: 38.887717 -83.375499

STEAM FURNACE, OHIO (ADAMS COUNTY) — CLASSIFICATION: SEMI-GHOST TOWN
The abandoned Turkey Creek Church is at the intersection of State Route 781 and Lucas Road. Steam Furnace grew up around an iron forge constructed in 1815 and an iron furnace the following year. The town's population is currently far less than it was during the community's boom days. The location of the forge and furnace have unfortunately been lost to time but there are also several other abandoned buildings and houses in the area. Steam Furnace Cemetery is on the west side of Steam Furnace Road north of State Route 781.

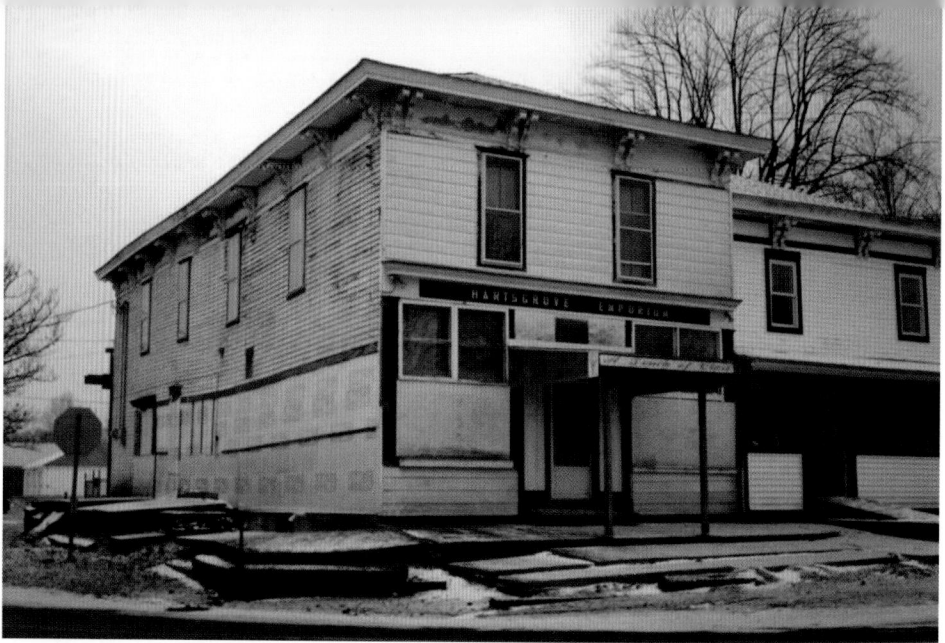

Hartsgrove Emporium, GPS Coordinates: 41.605346 -80.953275

HARTSGROVE, OHIO (ASHTABULA COUNTY) — CLASSIFICATION: SMALL TOWN
Hartsgrove was founded in 1830 and still retains much of its old charm within the town square. It has a roundabout where US Route 6 meets State Route 534 and the interior has a park with a gazebo and a couple of historical markers. The Hartsgrove Emporium along the roundabout once featured historical exhibits and housed a museum honoring the presidents of the United States but is now empty and unused.

A restored one-room schoolhouse stands near the town square and looks well maintained. There is also a restored general store that continues to operate, two old churches, and a former meeting hall in the area. Hartsgrove is one of the most quaint and peaceful towns we have visited while on an exploring trip. Being in the square almost feels like stepping back in time.

Hartsgrove School, GPS Coordinates: 41.606180 -80.953966

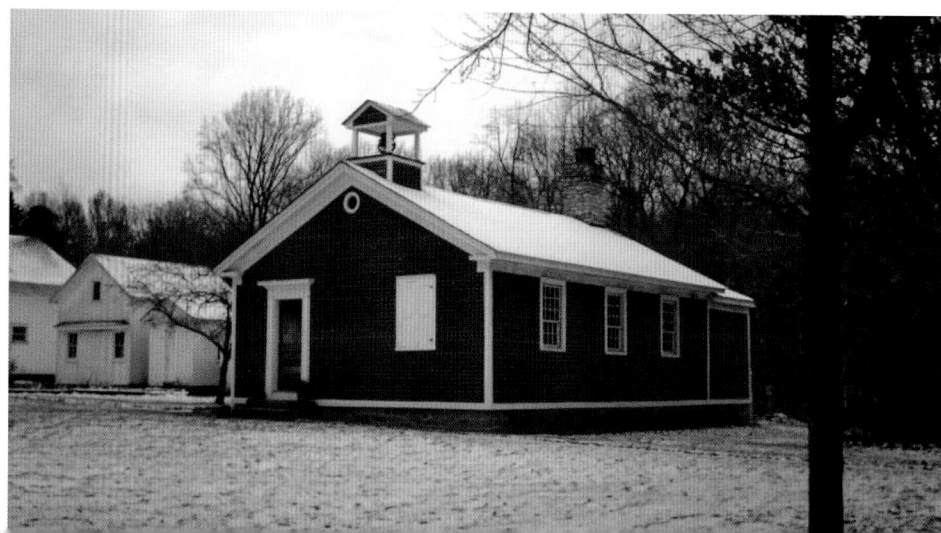

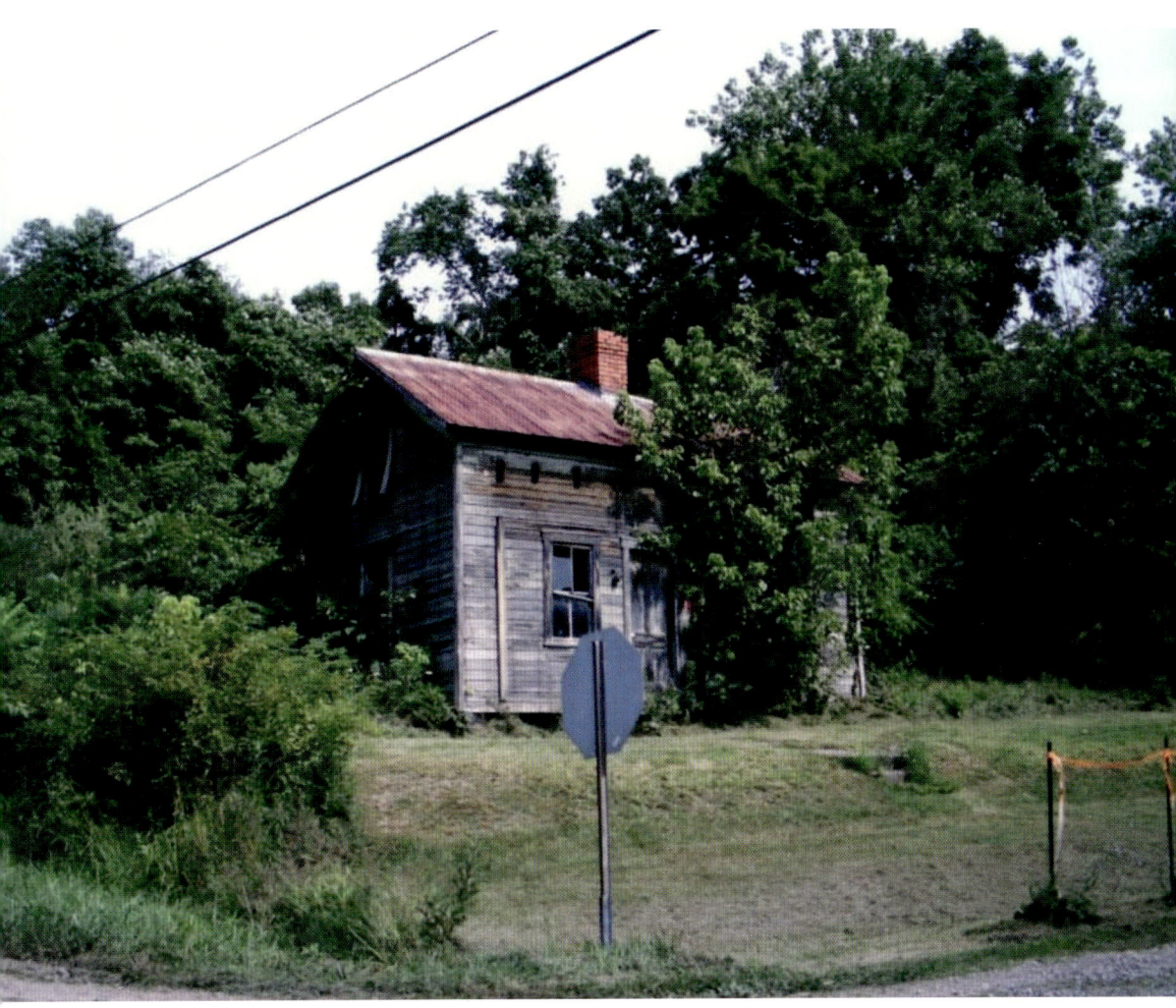

Broadwell House, GPS Coordinates: 39.365398 -81.880834

BROADWELL, OHIO (ATHENS COUNTY) — CLASSIFICATION: SEMI-GHOST TOWN

When mining production stopped and train stations were abandoned in small towns during the 1800s and early 1900s, many residents left to find work elsewhere and Broadwell was no exception. The original settlers in the area were Henry Broadwell (1809-1881) and Anne Eliza (Wainwright) Broadwell (1813-1890). Their daughter, Ann Eliza Broadwell (1846-1931), was a prominent land owner and entrepreneur. She turned the settlement into a town and donated land for a train station on the Federal Creek Railroad.

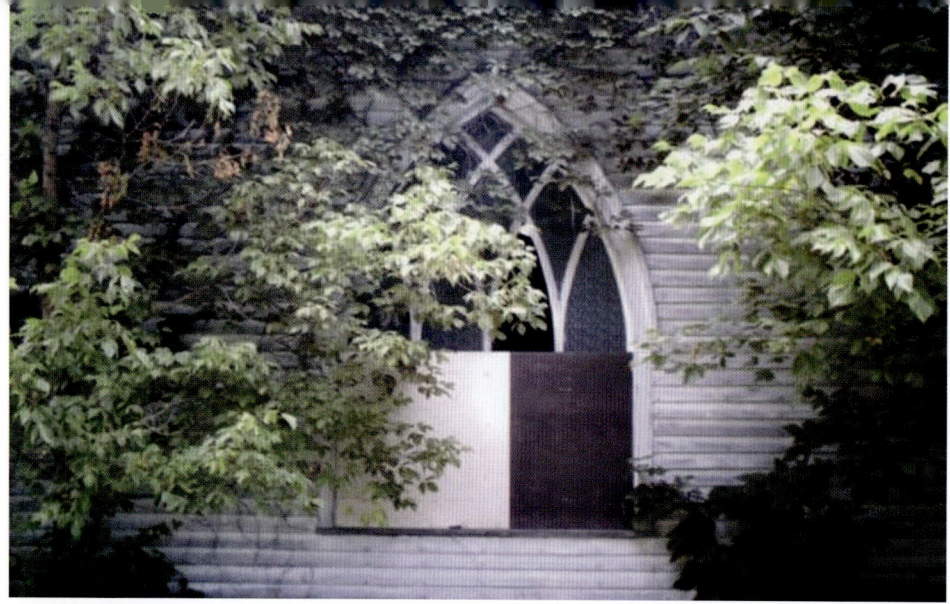

Broadwell Church, GPS Coordinates: 39.365678 -81.880346

It's almost tough to imagine how much things must have changed while driving through Broadwell on Sand Rock Road and making the turn onto Broadwell Street. A good number of the old town's buildings defiantly stand the test of time along the narrow gravel road. Residents were employed by the Federal Coal Company, railroad, farming, and several smaller businesses to accommodate the population.

Although it's a neat place to explore any time of the year, we recommend going in late fall to early spring when the brush is easier to see through. We barely spotted the old abandoned church on Broadwell Street with one of its windows peeking out between some bushes and trees. The rest of it and some of the other old and abandoned buildings were almost completely concealed by nature.

Broadwell House, GPS Coordinates: 39.365480 -81.880565

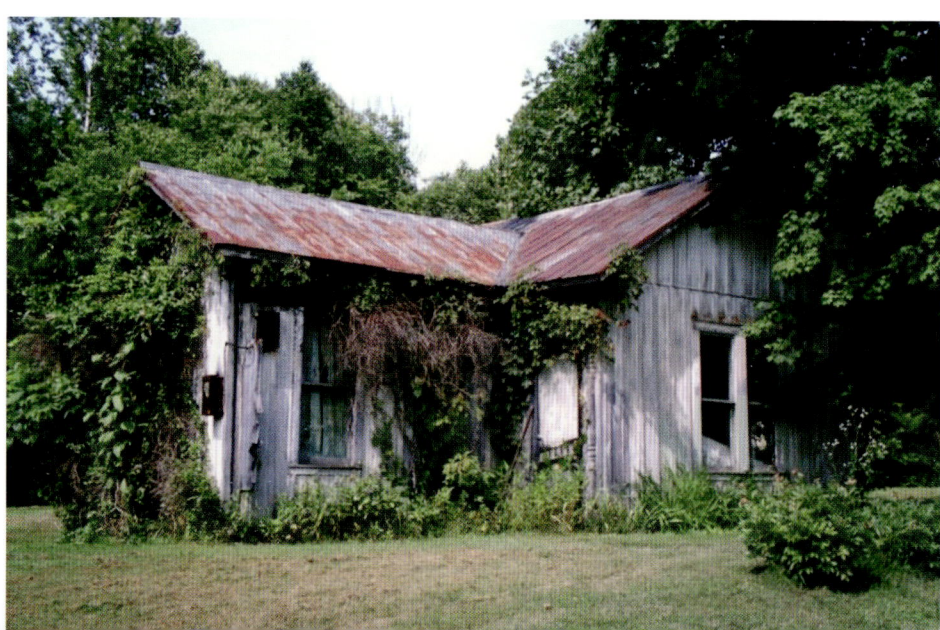

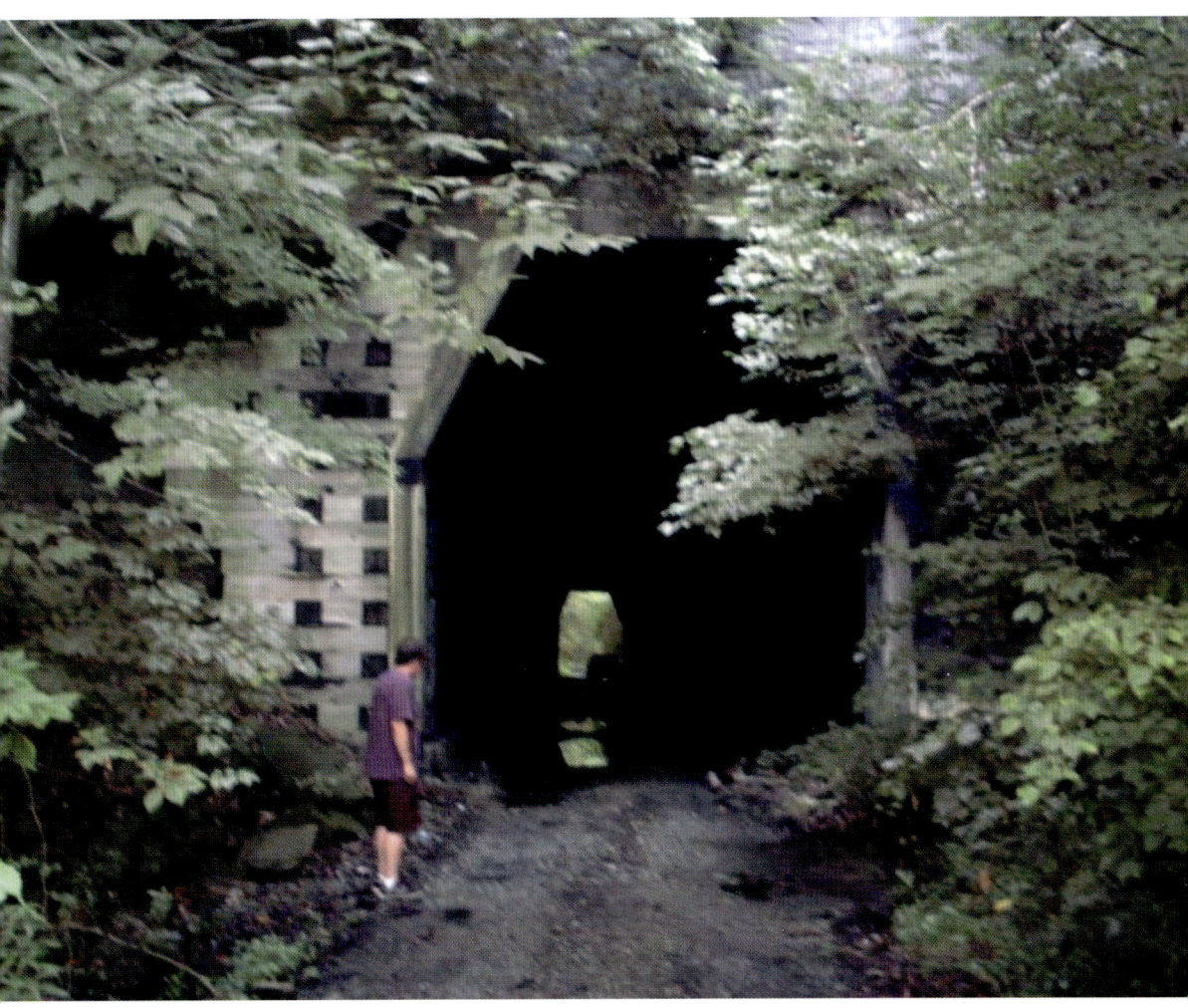

Kings Station Kings Hollow Tunnel, GPS Coordinates: 39.320974 -82.280652

KINGS STATION, OHIO (ATHENS COUNTY) — CLASSIFICATION: GHOST TOWN
Kings Hollow Tunnel is an awesome site to explore on the Moonville Rail Trail. It's along the former railroad track bed northeast of the intersection where King Hollow Trail meets Rockcamp Road. Silas D. King (1840-1909) donated land for a train station on the Marietta & Cincinnati Railroad and operated coal mines on his property. The tunnel was constructed in 1855 and the town had a general store, coal tipple, school, and several residences for workers lining the railroad tracks. Kings Station was abandoned in the 1910s after the coal mines closed.

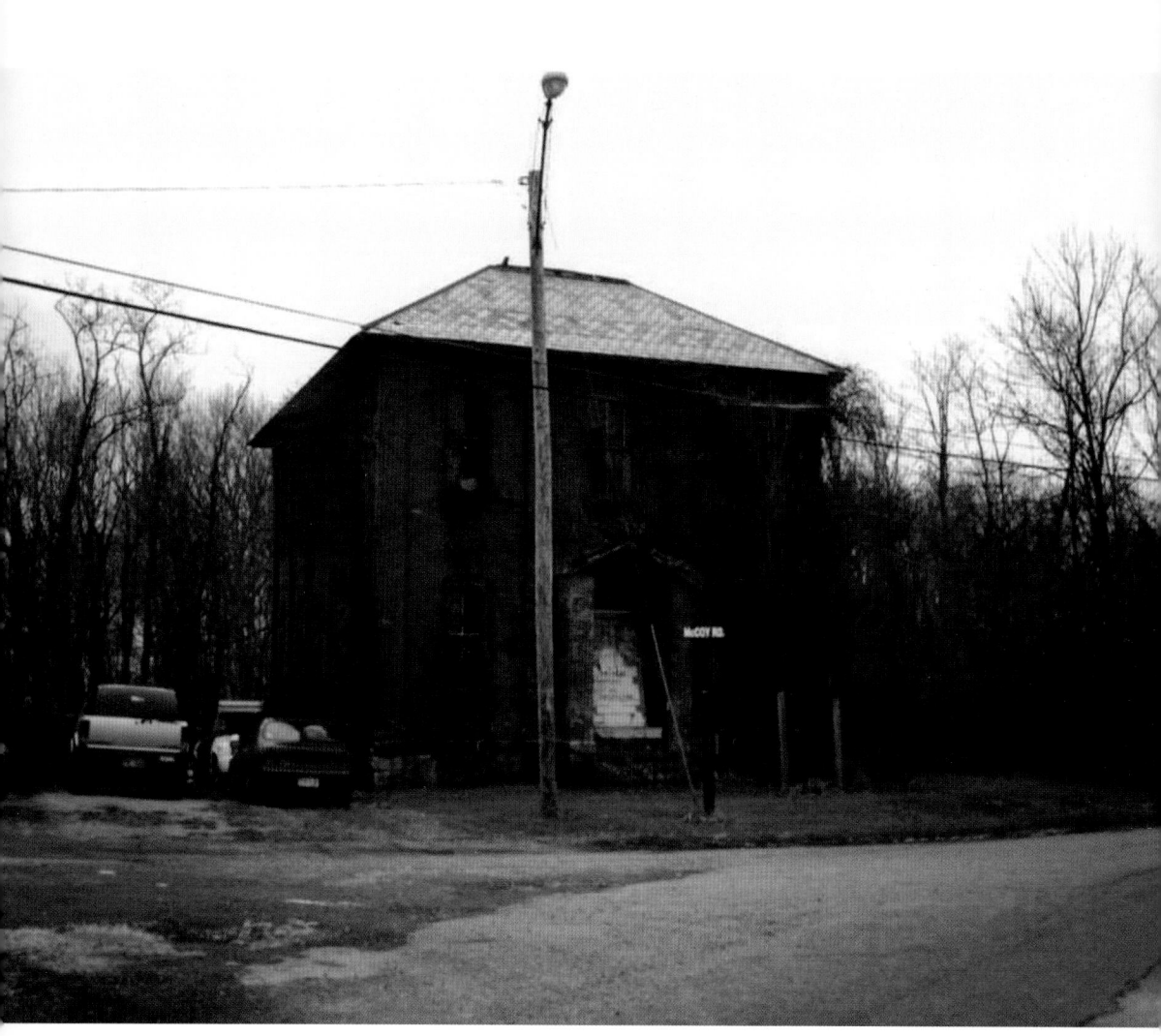

Sewellsville School, GPS Coordinates: 40.097787 -81.214242

SEWELLSVILLE, OHIO (BELMONT COUNTY) — CLASSIFICATION: SEMI-GHOST TOWN
The first site that noticeably stands out in Sewellsville is its former school at the intersection of State Route 800 and McCoy Road. The town was originally called Union and was founded by pioneers in 1815 who were attracted to the area by a cold-water spring which was a welcome relief for both them and their animals. Many had traveled weeks or even several months before arriving at the location and saw good enough reasons to stay.

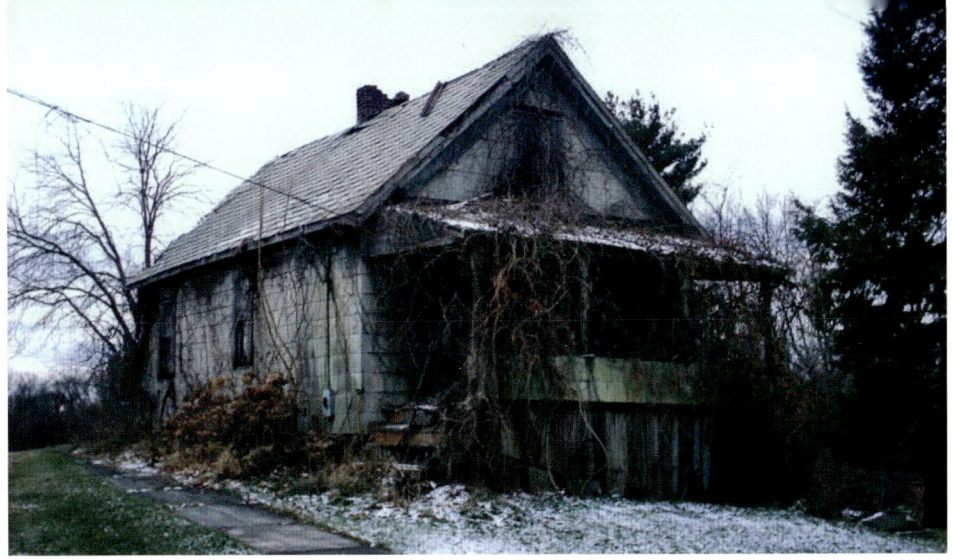

Sewellsville House, GPS Coordinates: 40.098409 -81.212365

The name changed to Sewellsville when Peter Sewell, a local carpenter, cabinet maker, and house builder, opened a post office in 1831. Farming and merchant shops were the main industries in the early to late 1800s. There were several dry goods stores, groceries, and other small stores throughout the decades. With no mills or factories, the town needed a new industry to keep it going in the next century.

Sewellsville began to thrive with surface coal mining and had a population of around 125 residents in 1900. Houses lined State Route 800 for several decades until the mining company started buying up more land to continue operation. By the time the company went out of business in the mid-1900s there weren't many houses left and those that remained were rapidly aging.

Sewellsville House, GPS Coordinates: 40.099255 -81.211386

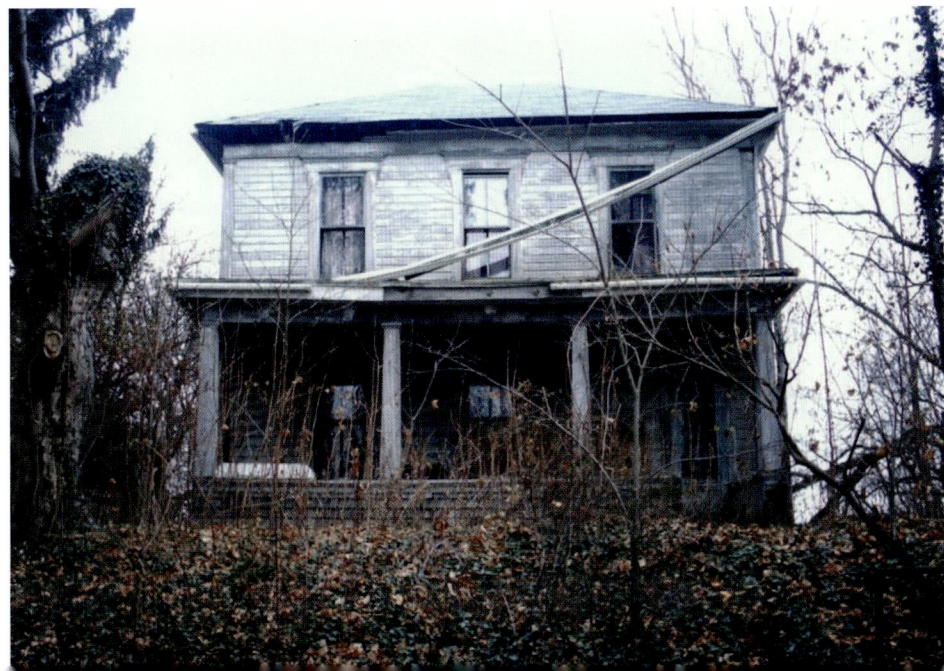

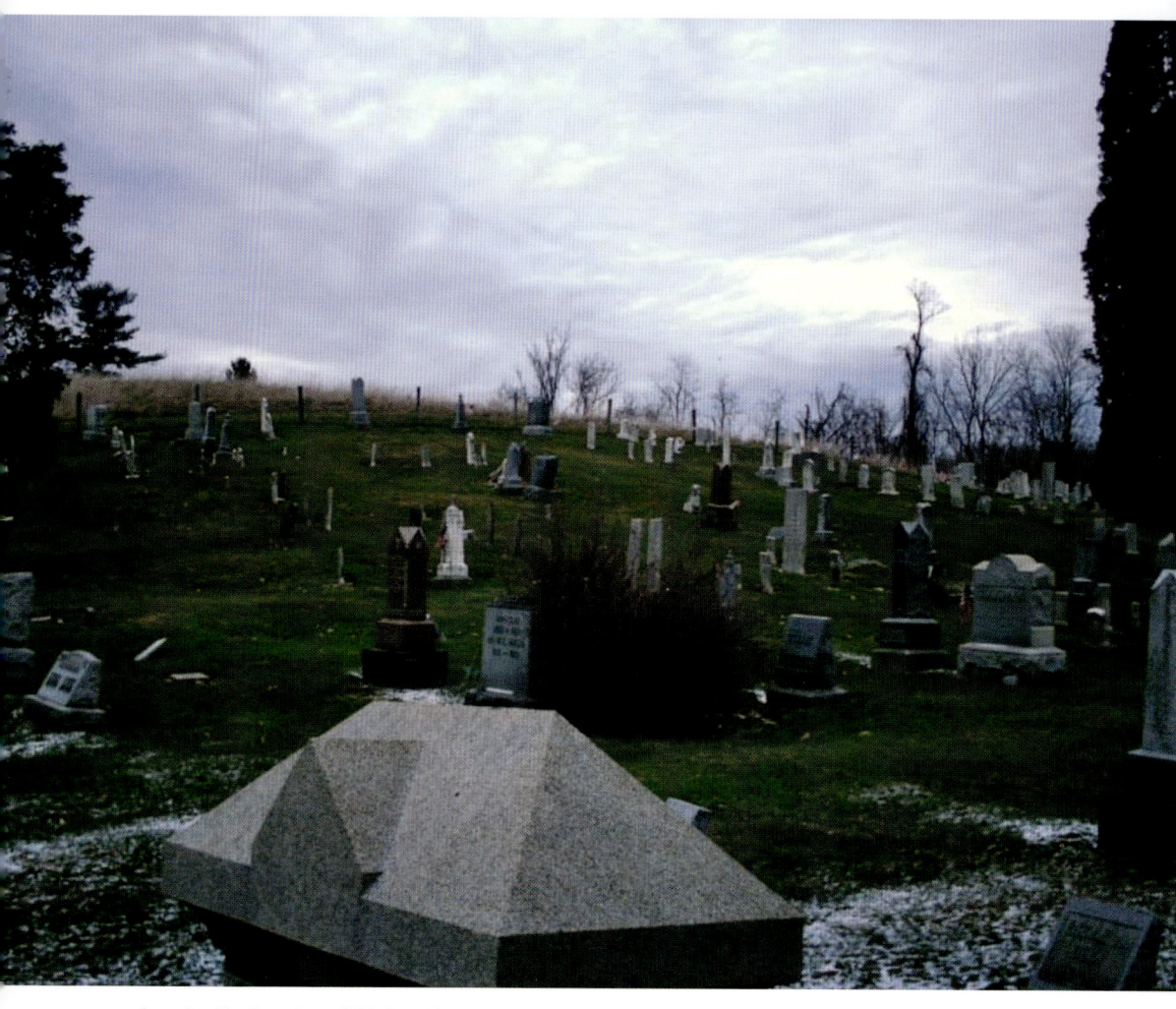

Sewellsville Cemetery, GPS Coordinates: 40.097805 -81.212164

Another interesting location in Sewellsville is its rather large cemetery next to an old and impressive looking United Methodist Church that's still in use. We suspect its size, when compared to the town, is mostly due to the town's age and not so much its population which is no larger than it was in 1900. The cemetery dates all the way back to the town's initial year of 1815.

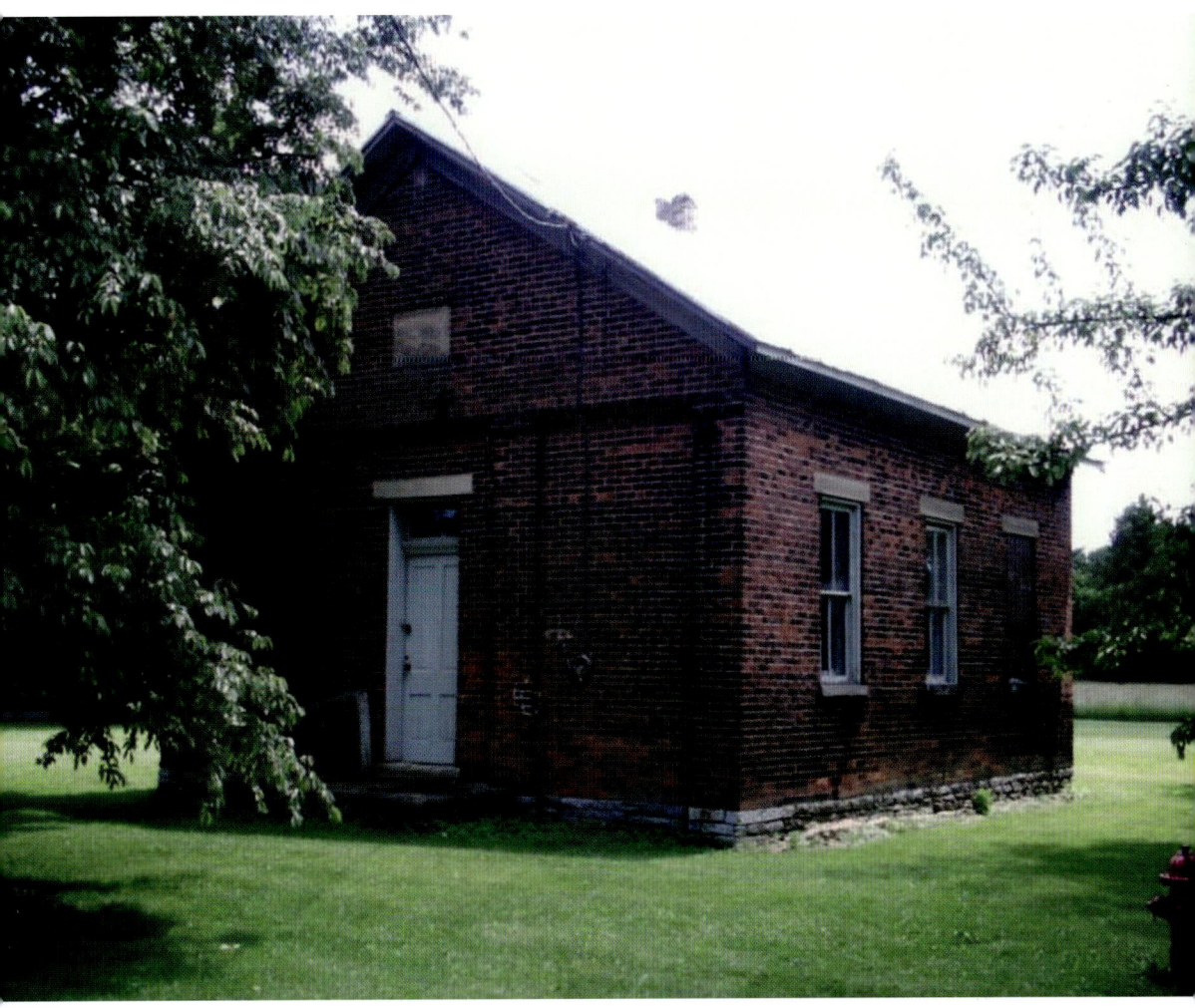

De La Palma School, GPS Coordinates: 39.070672 -84.011592

DE LA PALMA, OHIO (BROWN COUNTY) — CLASSIFICATION: GHOST TOWN

Ohio is blessed to have a good number of one-room schoolhouses from the 1800s that are still intact. A classic example is the De La Palma school at the intersection of Dela Palma Road and Bardwell West Road. It's the last public building left from a typical rural ghost town with newer residences in the area. De La Palma was founded by Absalom Day (1773-1839) and Elizabeth (Earhart) Day (1776-1843) who had twelve children, a nice farm, and were buried with relatives in Price Cemetery near the bank of Four Mile Creek.

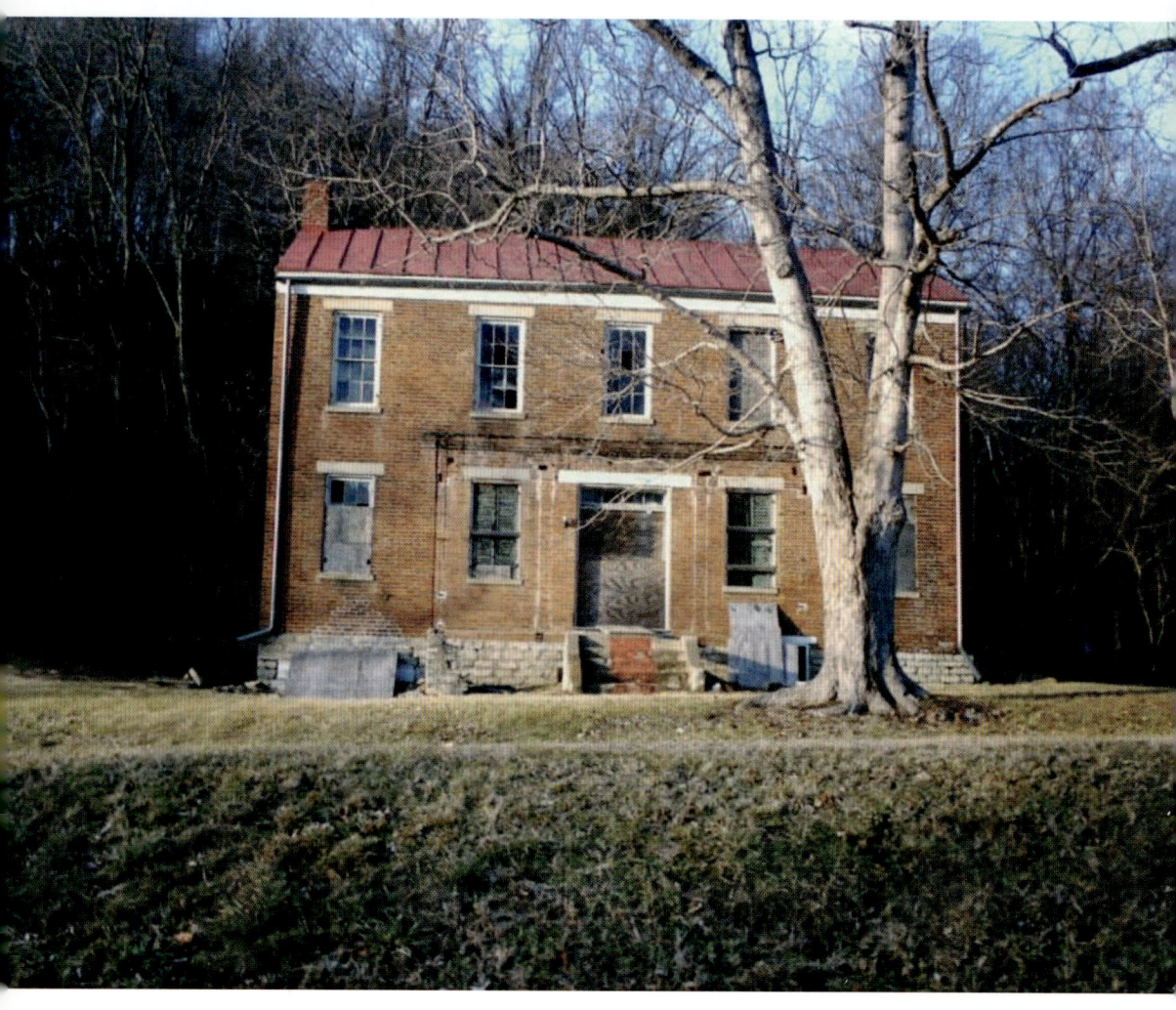

Higginsport House, GPS Coordinates: 38.778459 -84.035375

HIGGINSPORT, OHIO (BROWN COUNTY) — CLASSIFICATION: SMALL TOWN
Revolutionary War veteran Colonel Robert Higgins (1746-1825) platted Higginsport in 1816. It quickly boomed next to the Ohio River and grew to have 850 residents in the late 1800s. Corn and tobacco were the most profitable crops to raise. The town also had steam powered grist and saw mills, a whiskey distillery, seventeen tobacco shops at its peak of trade, and many other merchant shops. Higginsport never attracted a railroad and didn't have any major factories or businesses in the 1900s to keep it growing.

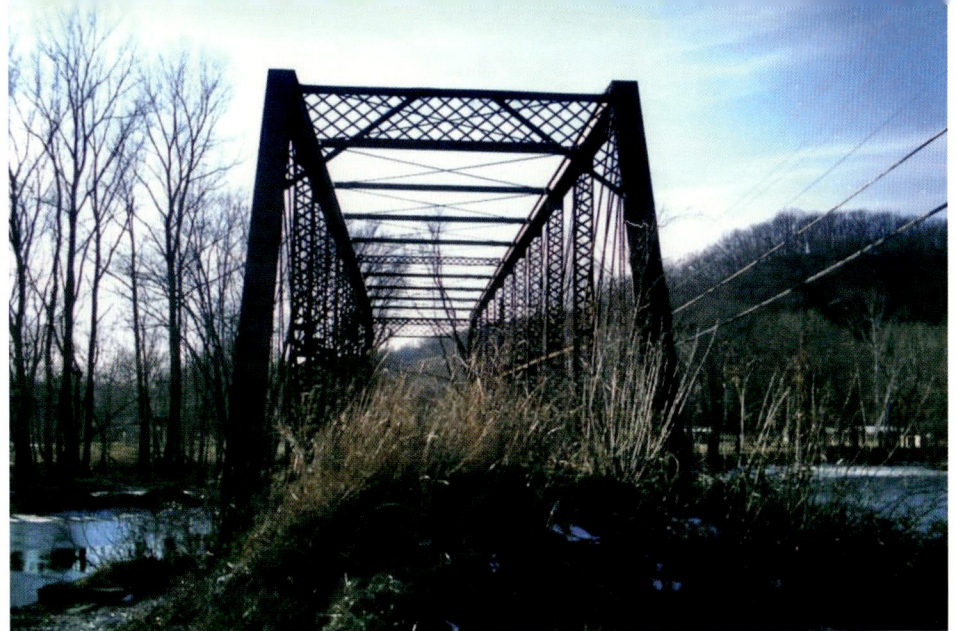

Higginsport Bridge, GPS Coordinates: 38.793454 -83.954991

The population is currently around 250 and likely still declining. As more residents move away, more buildings and houses get abandoned. Higginsport is on our endangered small towns list and could very well be classified as a semi-ghost town in the next decade. One of its coolest abandoned sites is a closed bridge crossing White Oak Creek on Old A and P Road that was built in the mid-1800s.

They're a bit tough to read these days, but some of the beams have a Carnegie steel company marker on them. Andrew Carnegie (1835-1919) was once one of the richest people in the world and supplied much of the country with the steel it needed for growth in the late 1800s. The bridge has a lot of character and the craftsmanship is easy to spot. It looks like every rivet was placed with precision and care of doing the job right.

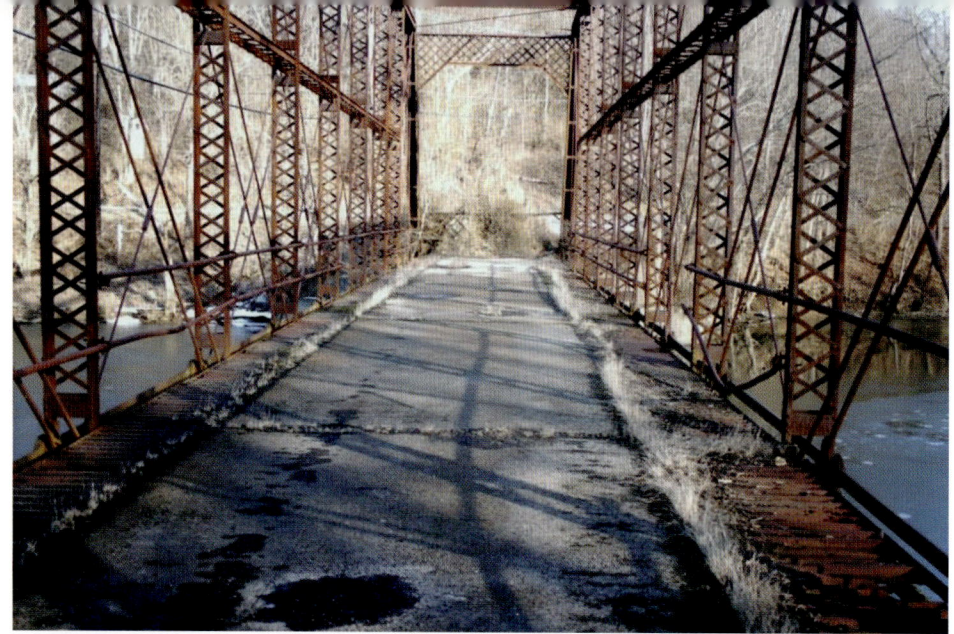

Although the bridge was well constructed back in the day and isn't closed to the public, we wouldn't exactly recommend walking across it just for fun or to take pictures. The voyage certainly isn't for the faint of heart or anyone that has a problem with heights. It's a long drop down to White Oak Creek. The side rails are very rusty and can't be trusted to support any weight. It doesn't appear to get any maintenance at all and could collapse at any time.

One of the more obscure abandoned locations in Higginsport is the former jail on the south side of US Route 52 west of town. It's barely visible in summer with just the top half hovering above grass that grows very tall and doesn't get mowed, aside from a thin strip next to the road. The building appeared to be a very old stone house next to the river but someone who lives in town later confirmed it was the jail.

Higginsport Jail, GPS Coordinates: 38.787531 -83.981812

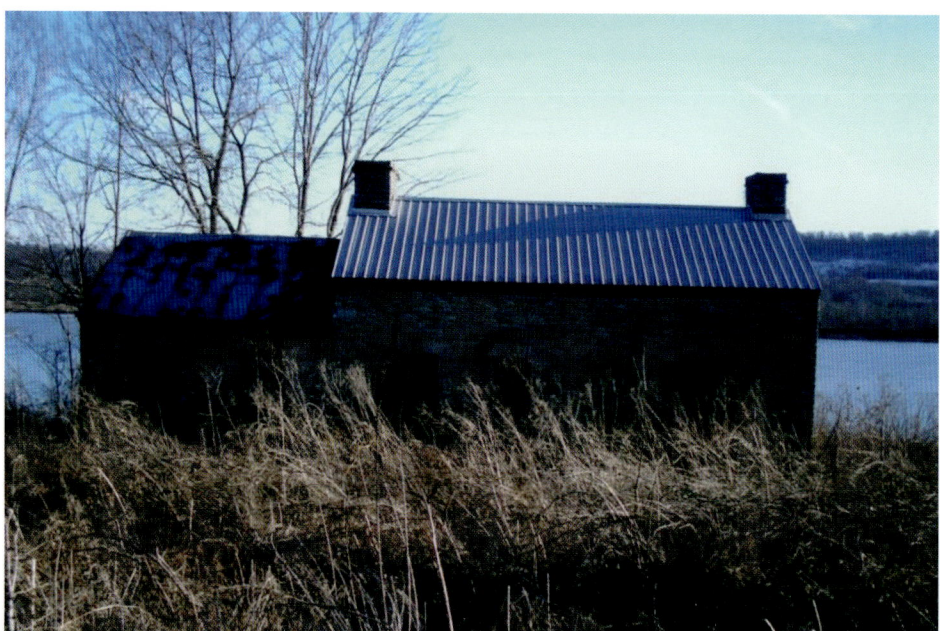

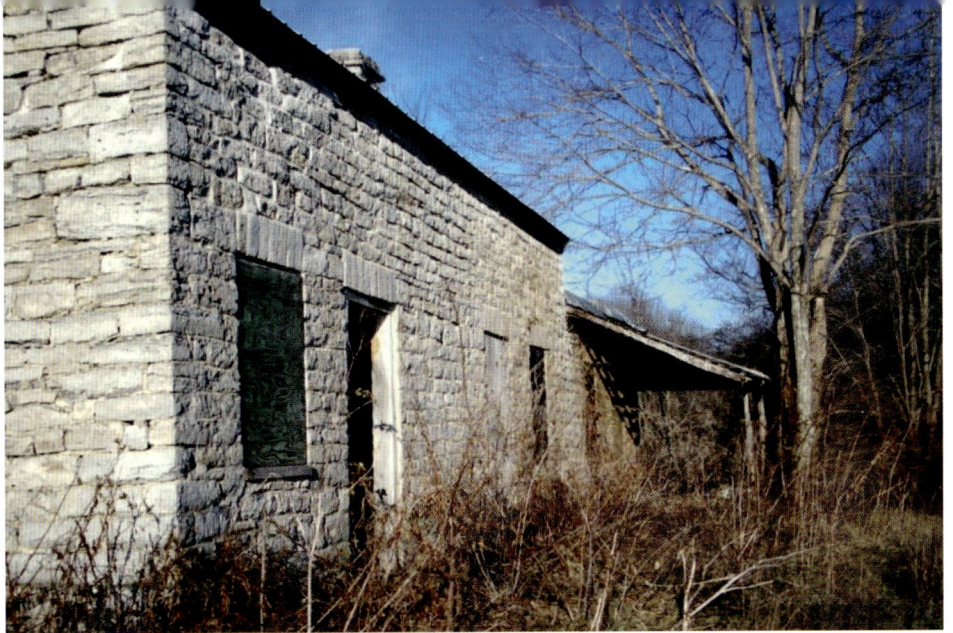

Dates of when it was constructed and closed couldn't be found, but it's unlikely the jail was still in use by the 1900s. There's a stone fireplace inside and the floor is bare dirt. The roof appears to be relatively new compared to the rest of the structure. The building is in amazing shape for its age with thick walls made of local creek stones that don't seem to mind the vast changes in Ohio's weather from season to season, or even day to day.

An interesting legend attached to the jail is the reason behind its close proximity to the Ohio River. For a shackled prisoner let out the back door to get some air, attempting to swim to freedom across the river wasn't an option they were normally willing to take. The guards didn't have to keep much of an eye on the back of the house which is just around twenty feet from a steep grade down to the water.

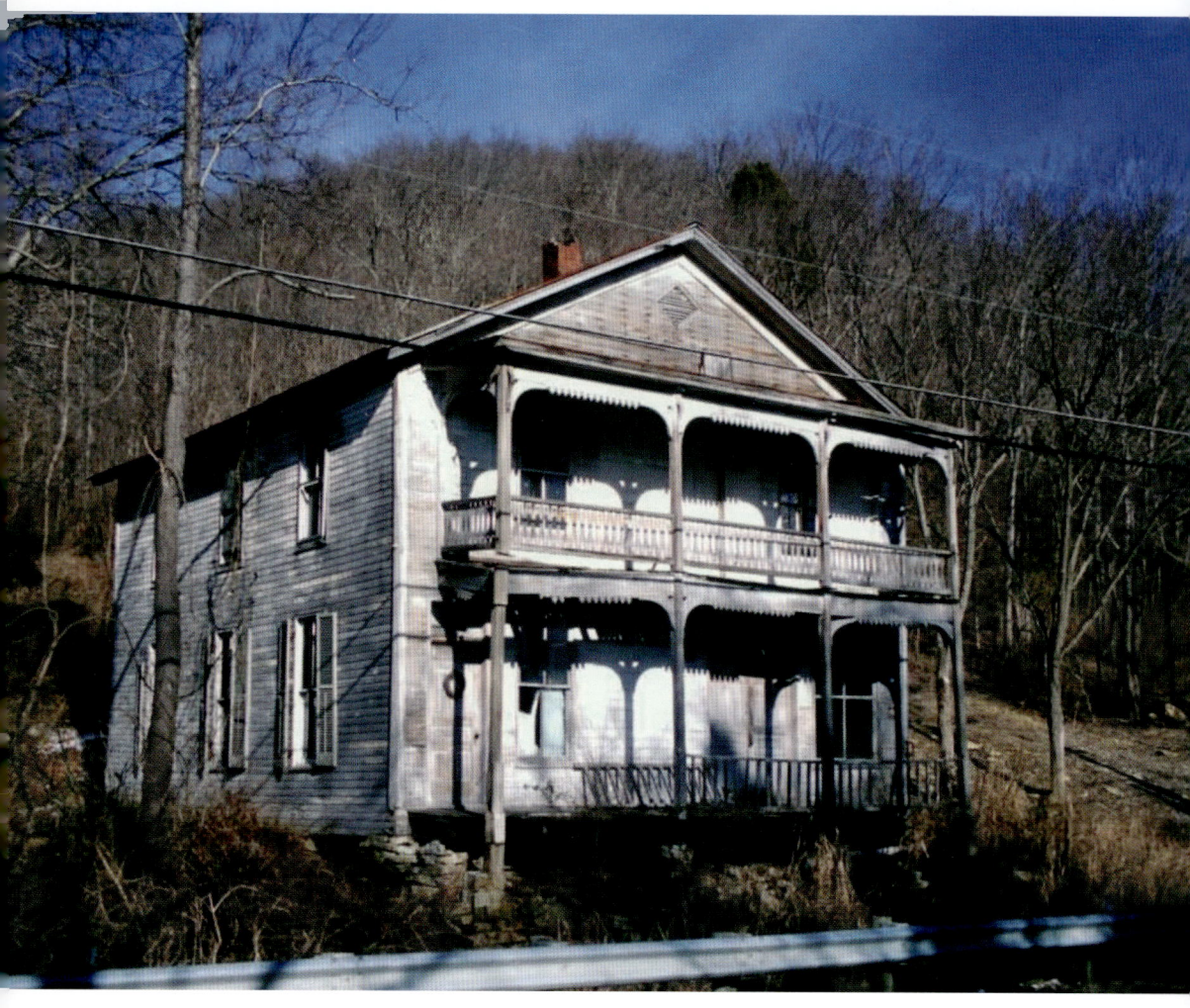

Levanna Hotel, GPS Coordinates: 38.766307 -83.883219

LEVANNA, OHIO (BROWN COUNTY) — CLASSIFICATION: SEMI-GHOST TOWN
This is another old Ohio River town that used to bustle with activity. Levanna's main source of income in the first half of the 1800s was vineyards. That changed in the mid-1800s as mills and factories moved in. Cheap trading costs with the other flourishing river towns along present day US Route 52 created population booms in the late 1800s, the likes of which those towns had never seen before, and unfortunately may never see again. The former hotel at the intersection of US Route 52 and Pisgah Hill Road hangs on to what little grandeur is left in the town.

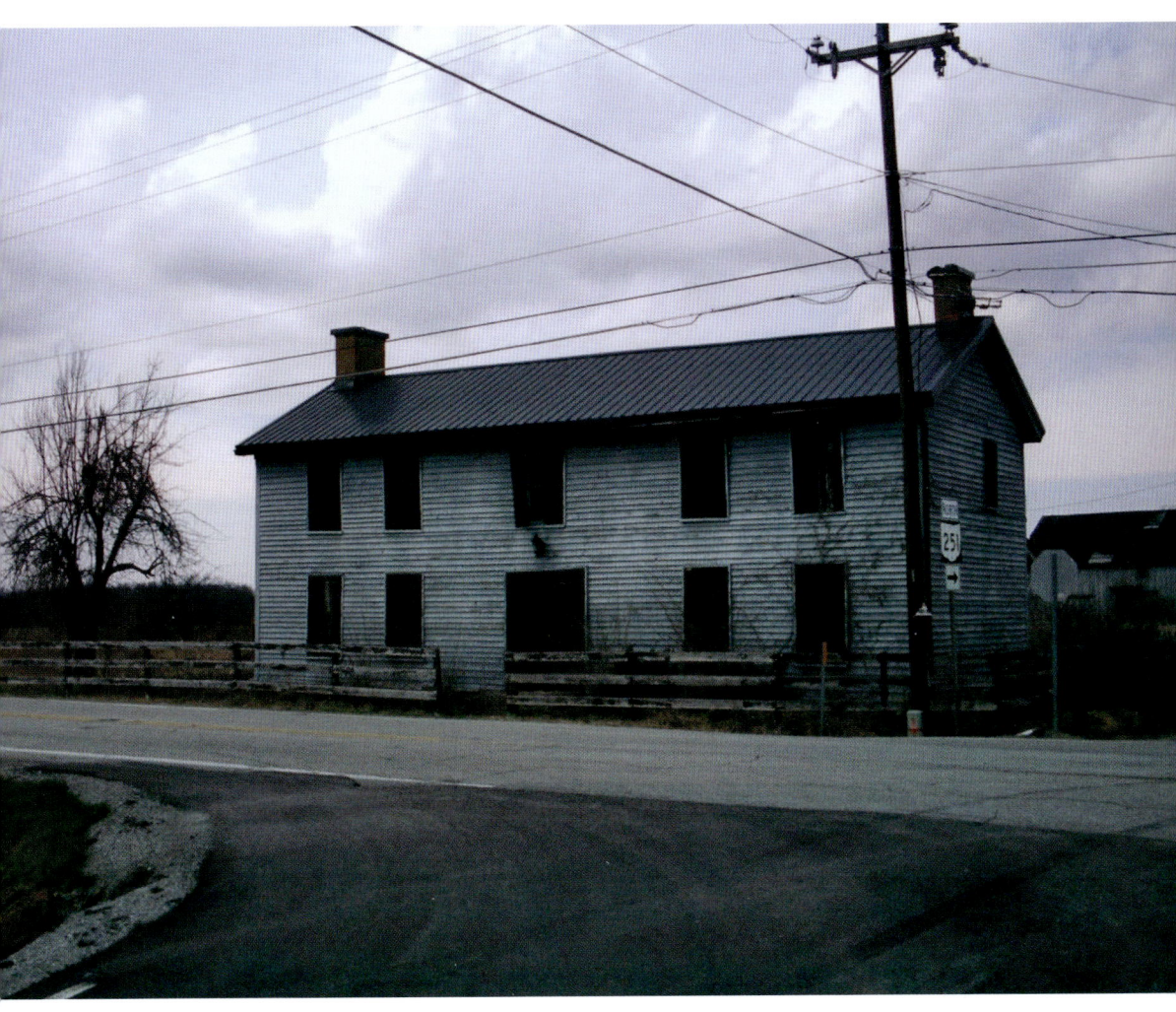

Murrays Corner Stagecoach Stop, GPS Coordinates: 39.191212 -83.897196

MURRAYS CORNER, OHIO (BROWN COUNTY) — CLASSIFICATION: GHOST TOWN

If walls could talk, the Thumann Log House would surely have a book full of stories to tell. It's the last known remnant of the ghost town and sits at the intersection of US Route 50 and Murray Corner Road. The original structure was a log cabin built as a tavern in 1811. It was remodeled with wood frame in the 1840s and turned into an important stagecoach stop between Chillicothe and Cincinnati. Cornelius Murray bought the property in 1851 and operated the tavern and hotel into the 1900s. It was added to the National Register of Historic Places in 1975.

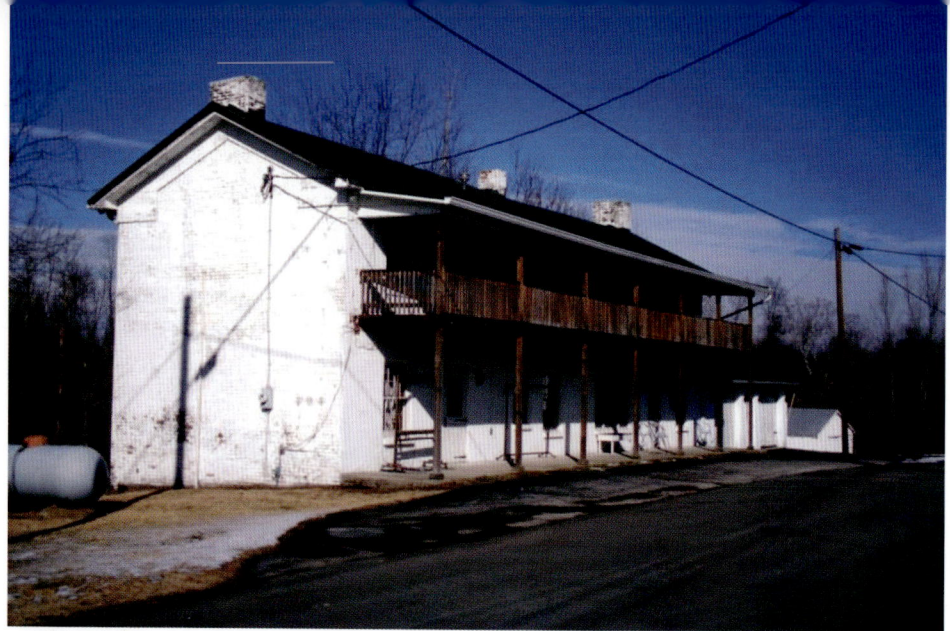

New Hope Stagecoach Stop, GPS Coordinates: 38.964130 -83.912880

New Hope, Ohio (Brown County) — Classification: small town

Daniel Holloway (1795-1842) and Dillany (Reynolds) Holloway (1795-1881) were the first settlers in the area in 1818. New Hope sprang up after more families moved in around them. The stagecoach stop on Main Street was constructed in 1846 and appears to be in great shape despite the lack of upkeep. It gives the impression of looking pretty much just like it did 170 years ago.

The town didn't grow much in the mid-1800s. It lacked big businesses and was hit hard by the cholera epidemic in 1849, which took the population back down below 100 residents. New Hope had some success starting in the 1870s with a wool mill, saloon, and three stores but it wasn't enough to create a population boom or attract a canal or railroad to increase the local economy. The town's last grocery store was in an old meeting hall and is across the street from the stagecoach stop.

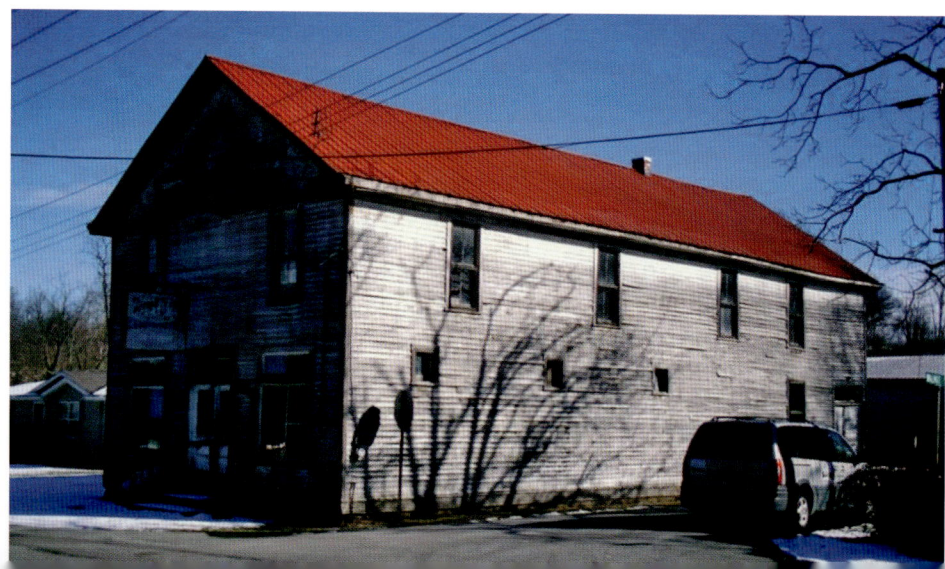

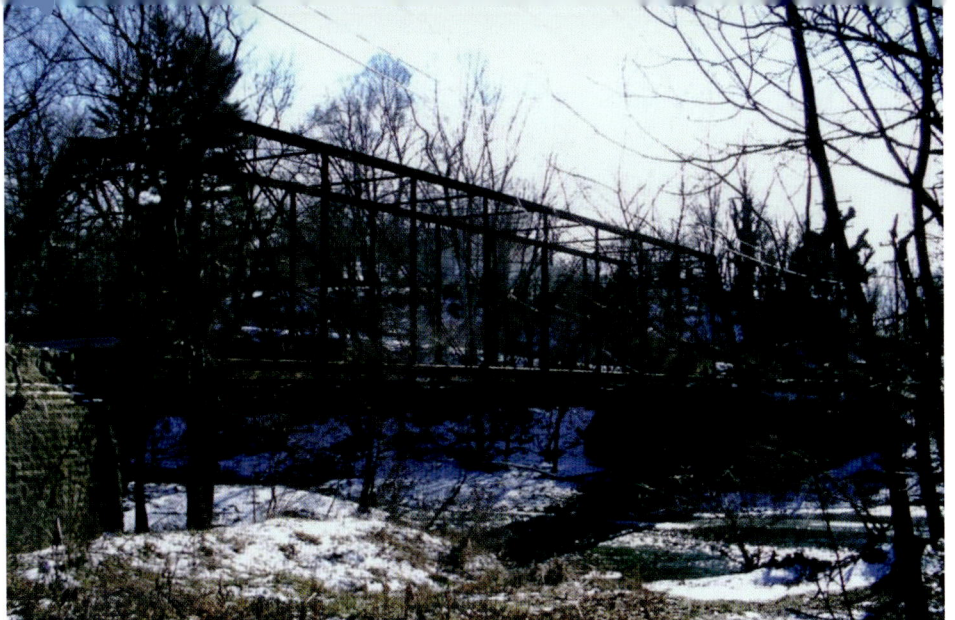

New Hope Bridge, GPS Coordinates: 38.965227 -83.911168

Past the stagecoach stop and grocery store on Main Street a closed iron bridge built in 1884 spans White Oak Creek along the path US Route 68 used to take. Just like the bridge in Higginsport, it's very rusty and the side rails can't support any weight, so stay in the middle as much as you can if you must cross it. Some of the wooden floor beams are rotting out and holes in them are getting bigger every year.

The bridge was constructed at a crucial time. Otherwise, there wouldn't have been easy access into town and New Hope could have faded out of existence in the early 1900s before US Route 68 was improved. The population remains intact and it isn't in danger of becoming a semi-ghost town anytime soon. There weren't any abandoned houses in the area and the stagecoach stop, although not in use, is maintained.

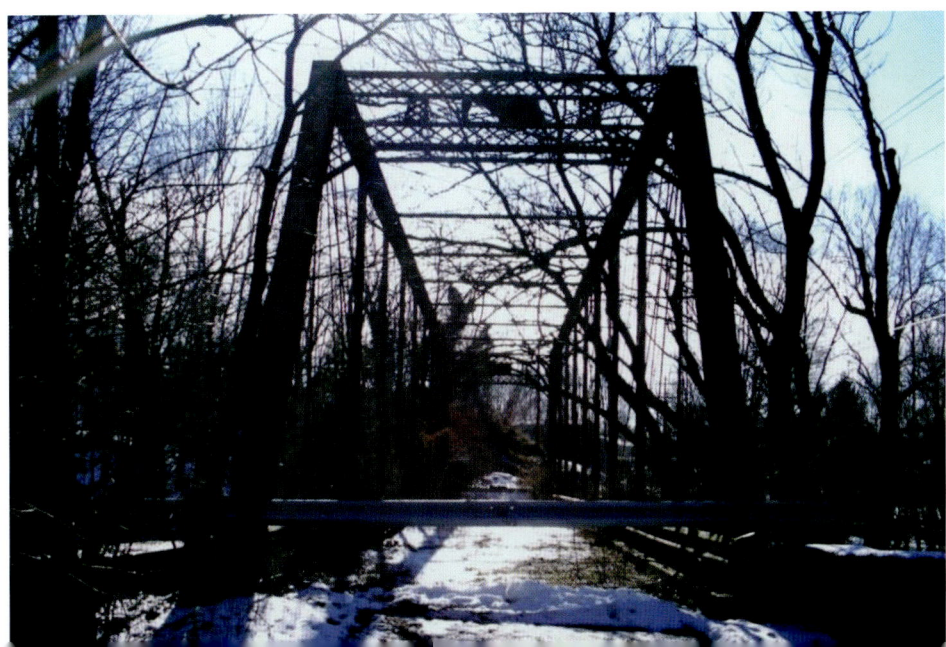

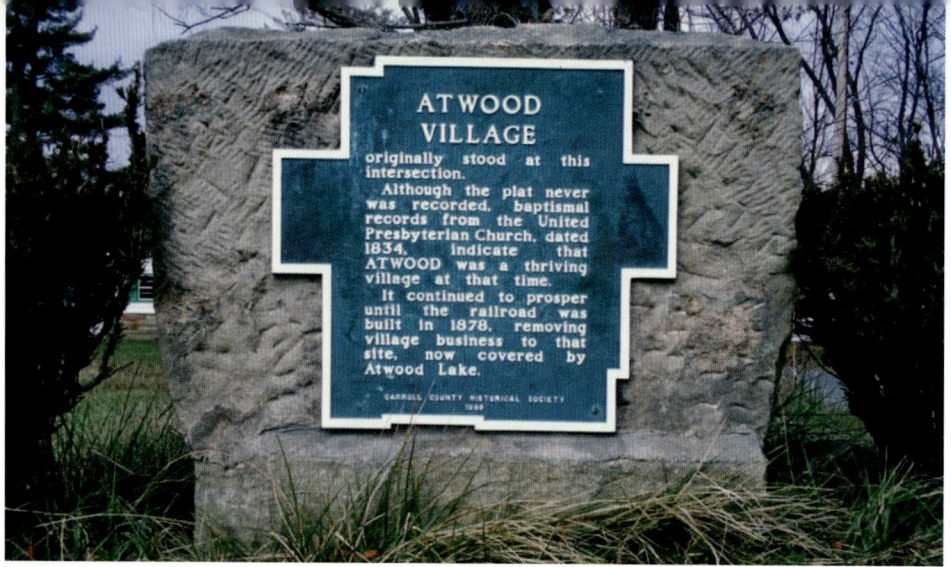

Atwood Historical Marker, GPS Coordinates: 40.547062 -81.238249

Atwood, Ohio (Carroll County) — Classification: ghost town

As with any chunk of land and what people want to put there, it's all about location, location, location. It can make or break a town and in Atwood's case, did both. Called Oak Dale as early as the 1820s, Atwood did well in the mid to late 1800s and had a train station on the Cleveland, Canton, & Southern Railroad. The historical marker at the intersection of State Route 542 and Fargo Road tells a bit more of the tale.

The dam and adjoining lake were completed in 1936 by the US Army Corps of Engineers. There are at least a couple dozen underwater ghost towns around Ohio that met the same intentional and watery demise. Residents had two choices: they could spread out along the new water edge or had to move away from the area to a new life somewhere else. Some didn't have enough time or money to move everything and lost more than what the government compensation was worth.

Atwood Dam Historical Marker, GPS Coordinates: 40.525938 -81.285241

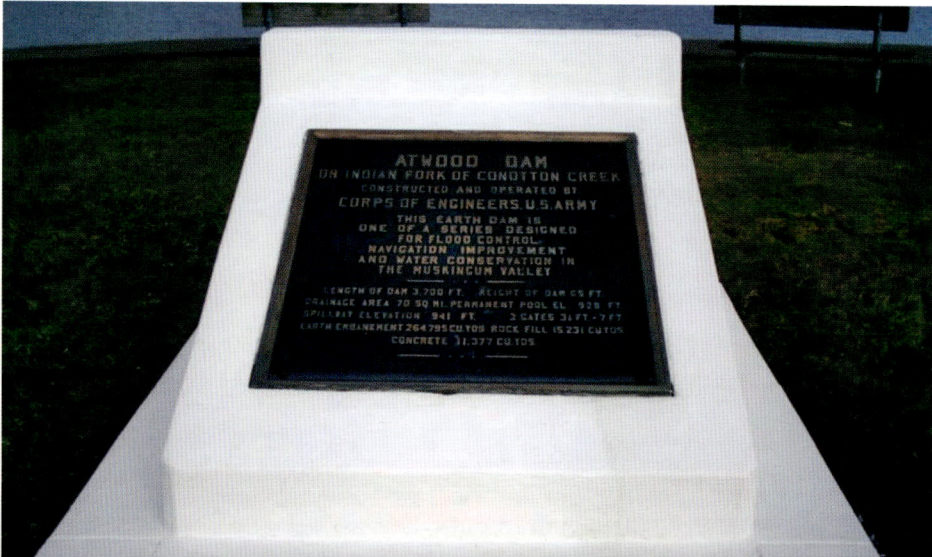

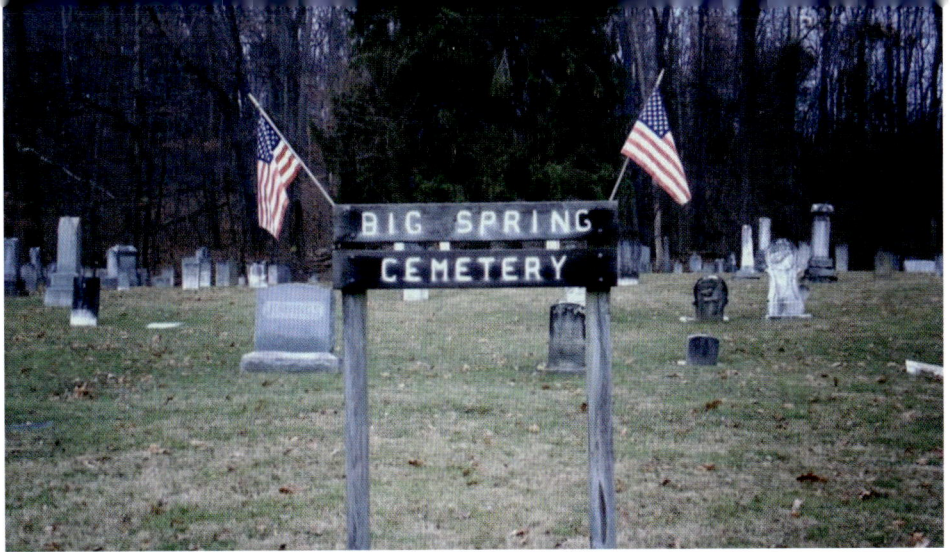

Atwood Big Spring Cemetery, GPS Coordinates: 40.558033 -81.254640

Atwood had a lot more going for it than the average underwater ghost town. Along with its business district, train station, and several residences and farms, Big Spring Church was also lost to the lake. Many local pioneers and former residents of the town were buried in Big Spring Cemetery on the north side of Atwood Lake next to State Route 542. It's certainly a peaceful place and appears to look out over the water with memories of the past and good hopes for the future.

The cemetery slopes sharply toward the lake. Some of the gravestones were right at the edge and a few are likely underwater. Some residents were also buried in Zion Cemetery on Falls Road south of the lake. The area continues to go by the name Atwood and the lake has a lot of recreational activities to offer. The ability to explore some history while enjoying some modern outdoor entertainment makes it a great place for a day or weekend trip.

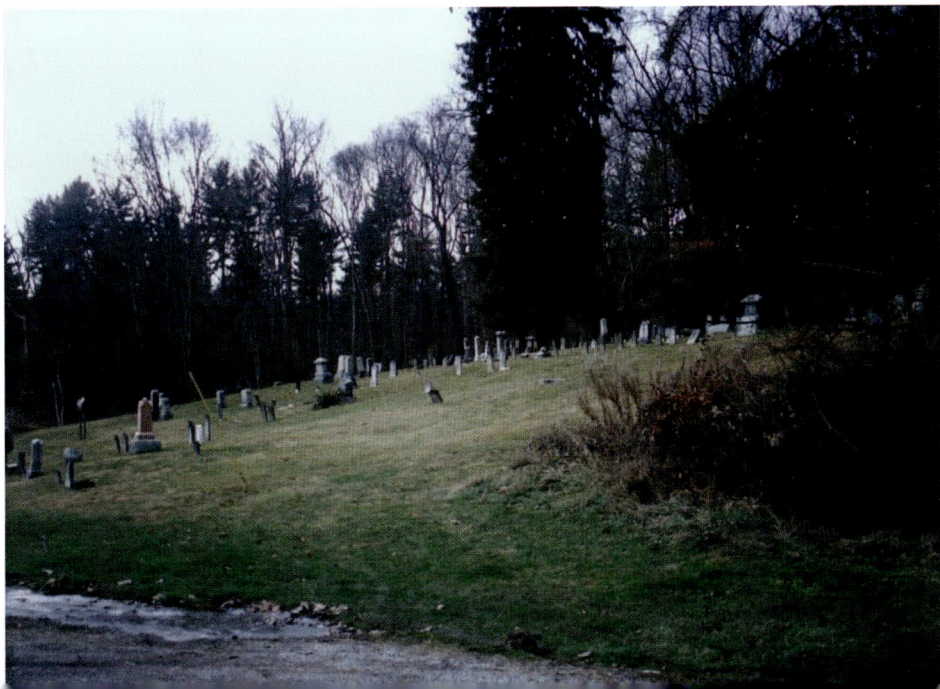

Amelia Train Station, GPS Coordinates: 39.031972 -84.223250

AMELIA, OHIO (CLERMONT COUNTY) — CLASSIFICATION: SMALL TOWN

Amelia has been steadily growing for 200 years and is as modern as any successful small town in Ohio. Traces of its historic past can be found along State Route 125. The Cincinnati, Georgetown, & Portsmouth Railroad rolled through the middle of Clermont County from 1878 to the late 1930s. Its tracks were torn out and sold for scrap after the railroad went out of business and there are few remnants left. The town's train station was moved across the street to its present location.

The station's companion railway express agency building sits in the same lot. They are in the process of being restored, and when completed, will be the most recognized landmarks of the nearly totally forgotten railroad. Many residents these days don't know it ever existed and weren't taught anything about it in school. Hopefully that will change in the future and kids will be given the opportunity to visit on class field trips. Visually learning about places like this is just as important as memorizing names and dates in history books.

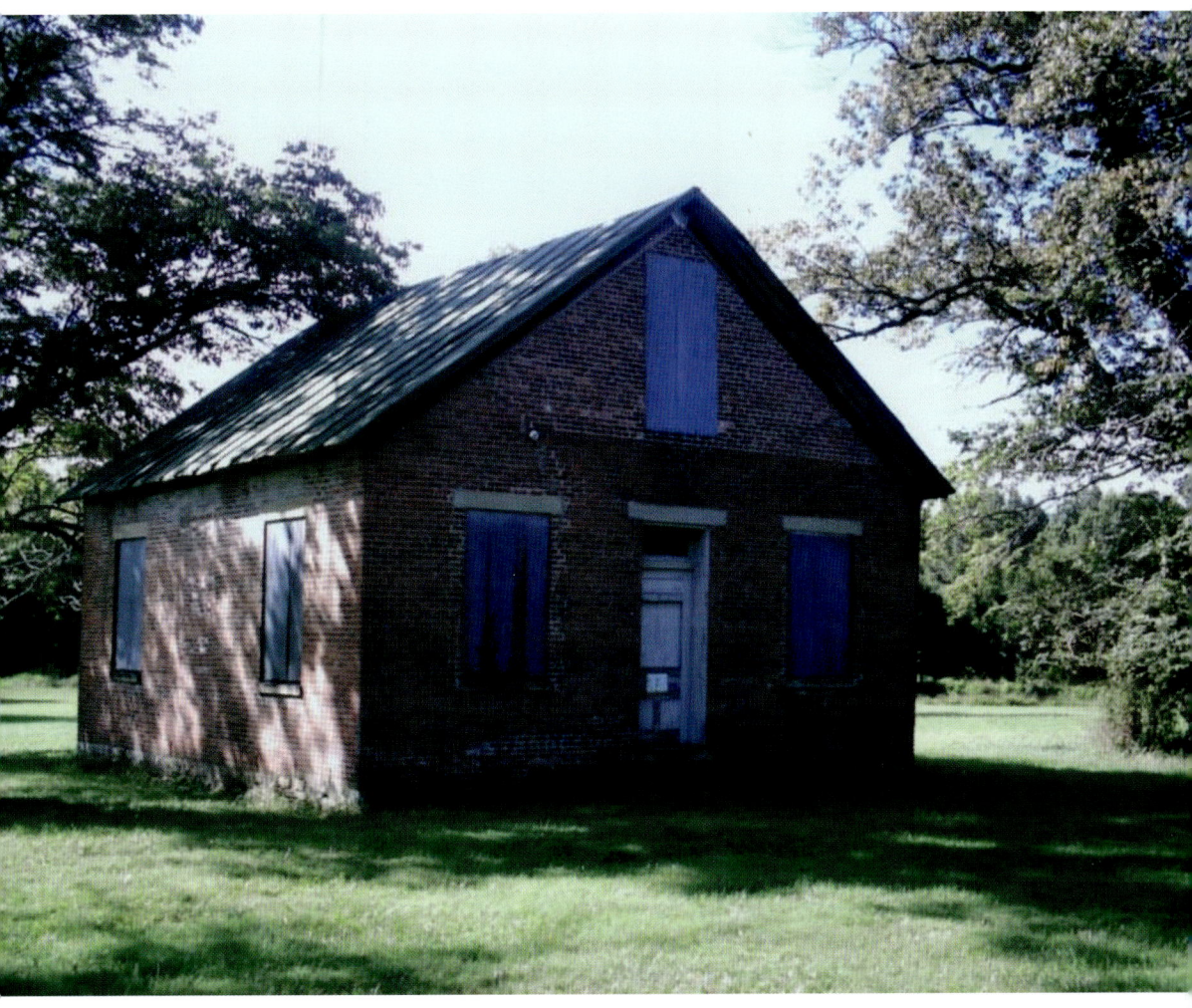

Bantam School, GPS Coordinates: 39.003108 -84.125600

BANTAM, OHIO (CLERMONT COUNTY) — CLASSIFICATION: SMALL TOWN
Bantam had two taverns, several mechanic shops, a carriage factory, and some merchant shops in the 1800s but didn't see much growth in the 1900s. It still has a few businesses and the main stretch of the village is on Old State Route 125. Its former schoolhouse sits on Williamsburg-Bantam Road northeast of town. Some of the residents of Elk Lick, highlighted later in this book, attended the school at Bantam.

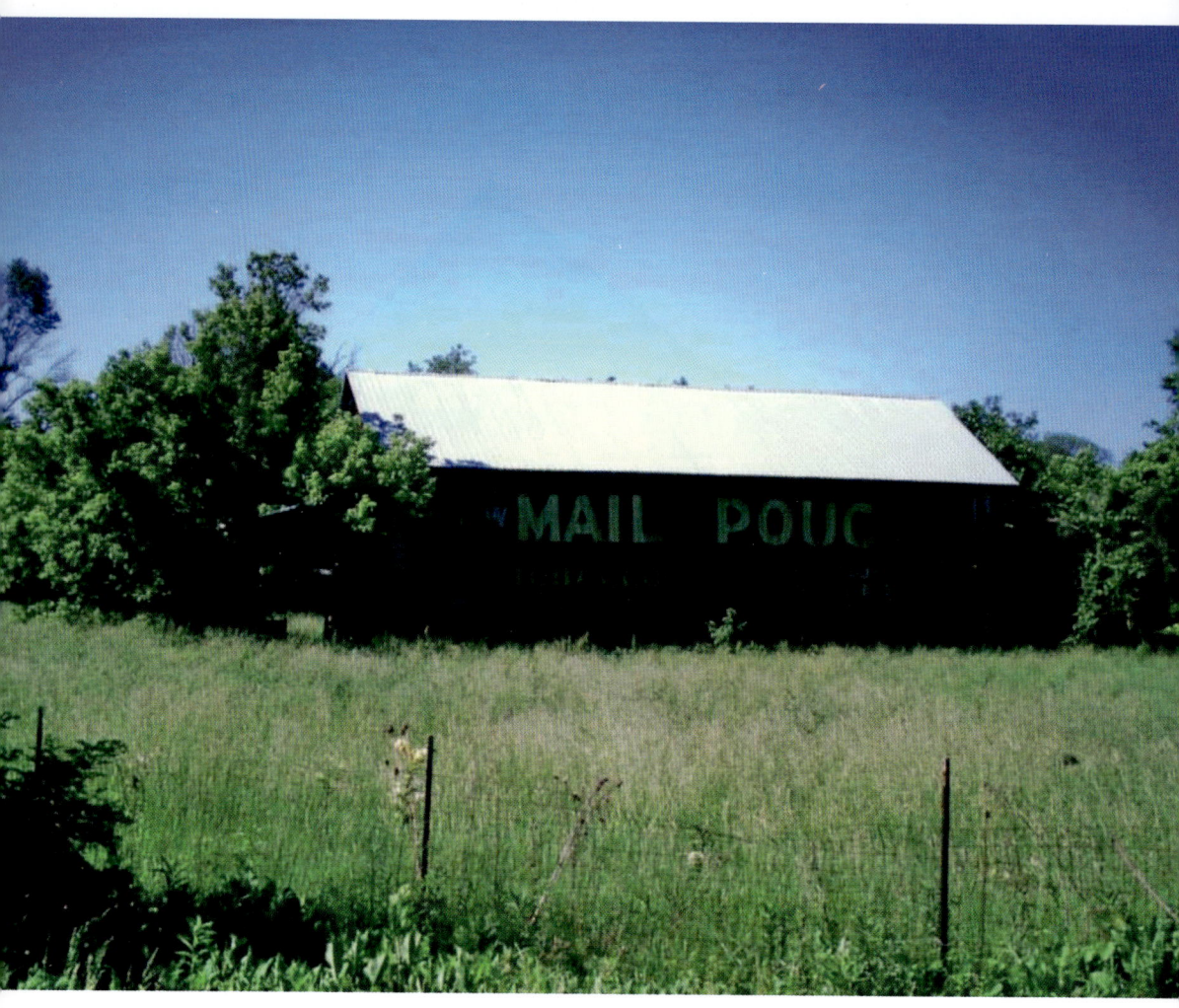

Batavia Mail Pouch Tobacco Barn, GPS Coordinates: 39.122050 -84.193367

BATAVIA, OHIO (CLERMONT COUNTY) — CLASSIFICATION: SMALL TOWN
Often seen around Ohio are the Mail Pouch Tobacco barns that dot the rural landscape. The barns were granted exception to the state's current laws, which ban tobacco advertising on billboards along roads, due to the historical importance of the barns. World War II veteran Harley E. Warrick (1924-2000) from Belmont County painted an estimated 20,000 Mail Pouch barns and signs during his 55-year career.

Swing Family Cemetery, GPS Coordinates: 38.974747 -84.108394

SWINGS, OHIO (CLERMONT COUNTY) — CLASSIFICATION: GHOST TOWN
Swings also had a train station on the Cincinnati, Georgetown, & Portsmouth Railroad along with a church and school. Some residents of the town, including its founders, were buried in Swing Family Cemetery on the north side of State Route 125 just west of Bethel. Much of the family moved out of state in the late 1800s and the cemetery is the only known remnant left, but there may be more along Swings Corner Point Isabel Road.

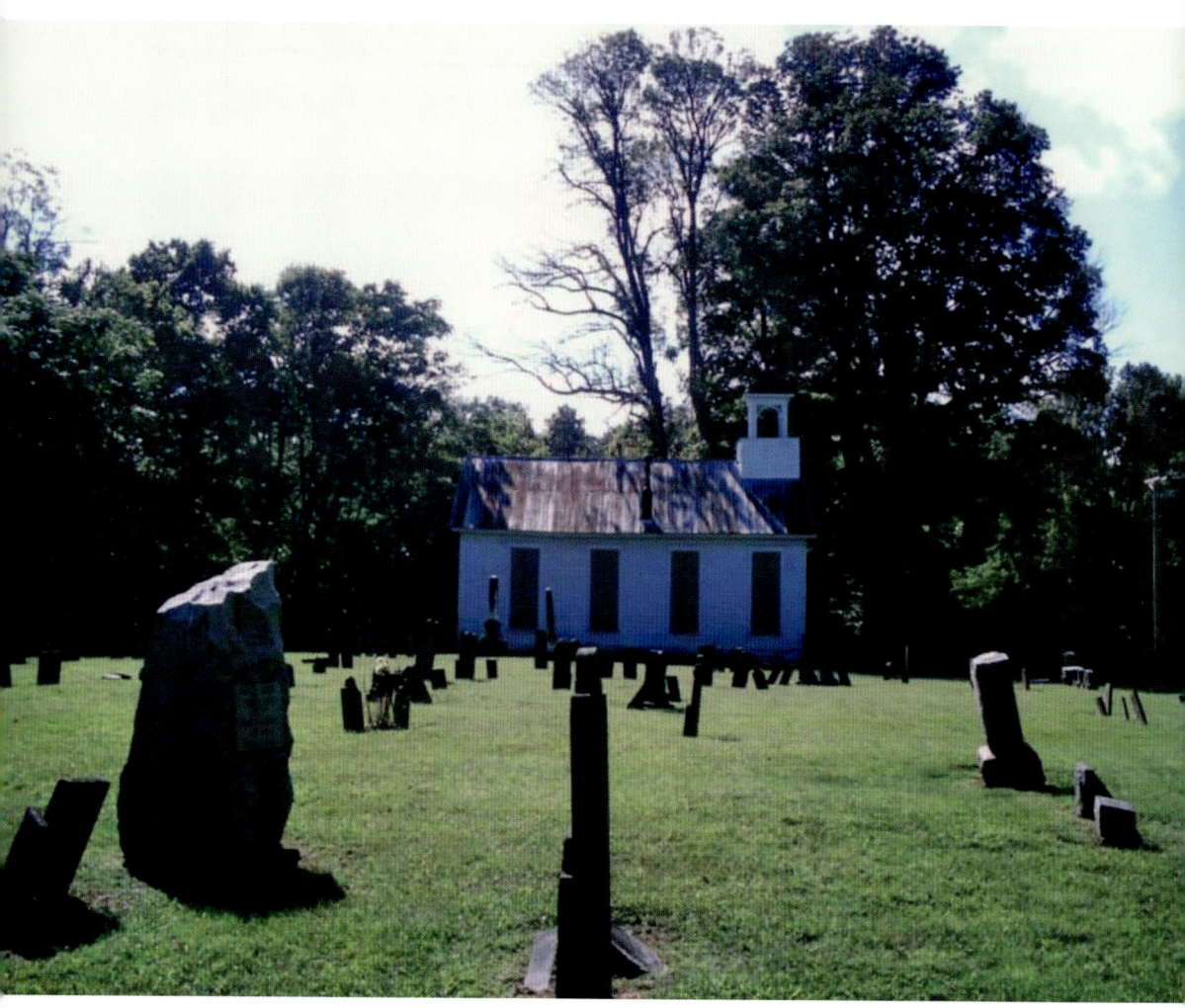

Elk Lick Old Bethel Methodist Church, GPS Coordinates: 39.007061 -84.138534

ELK LICK, OHIO (CLERMONT COUNTY) — CLASSIFICATION: GHOST TOWN

Reverend John Collins (1769-1845) and Sarah (Blackman) Collins (1776-1863) moved to Ohio from New Jersey and founded Elk Lick in 1805, naming it after the natural salt licks in the area. John built a log cabin chapel and formed a church congregation. The town once had hopes of becoming the county seat. That never happened, and Elk Lick turned into an underwater ghost town in the 1970s during the construction of East Fork Lake and dam. A few old homestead foundations can also be found near the lake edge.

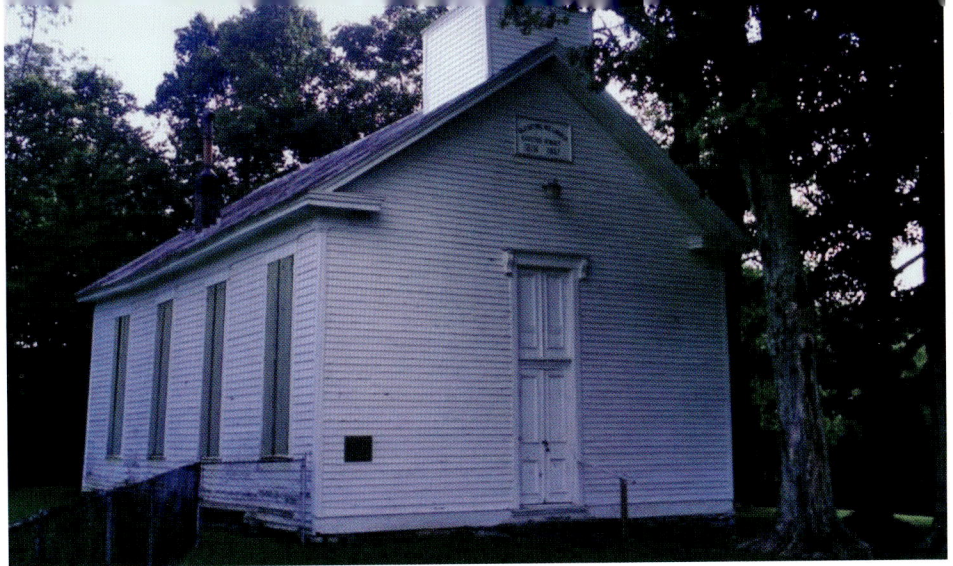

Collin's Chapel was replaced with a wood frame church in 1818. It was remodeled in 1867 and survived the town's destruction along with its cemetery on top of a steep hill well away from the lake valley. The church is still occasionally used for services and weddings and goes by the name Old Bethel Methodist Church. An American Civil War monument used for the base of a flag stand is along the path to the cemetery.

John and Sarah Collins were buried in the cemetery with relatives close to the church. One of their sons, Richard Collins (1796-1855), was a wealthy lawyer and had a 37-room mansion built in Elk Lick. It was considered to be the most elegant house in the county for several decades before falling into disrepair in the 1900s. The location was near the current recreational beach and the mansion was demolished prior to the lake completion. Several old farms, a few businesses, and a small gold mine were submerged.

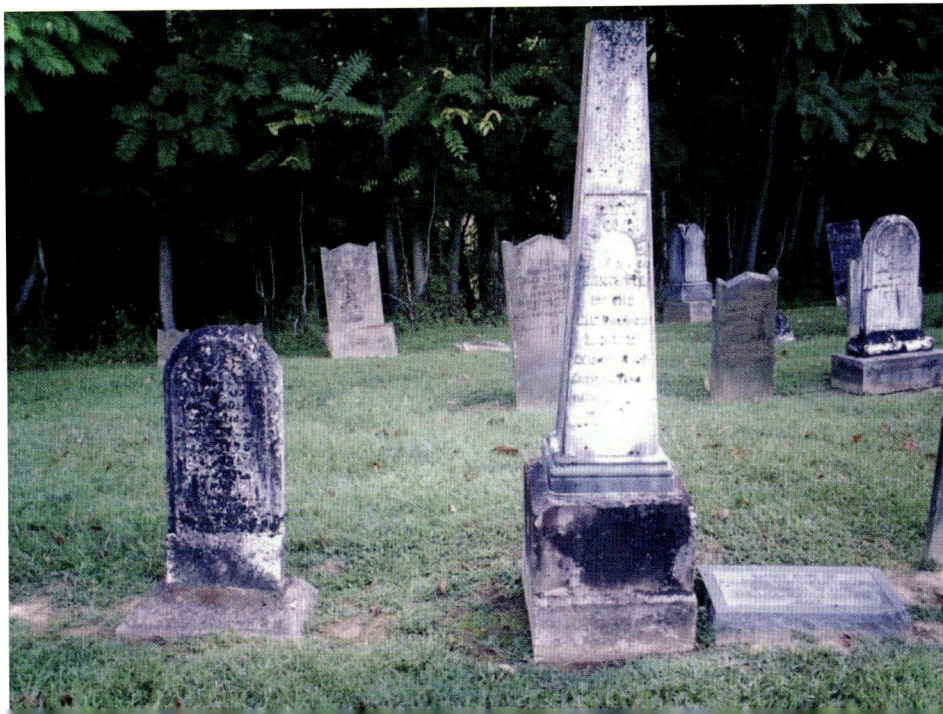

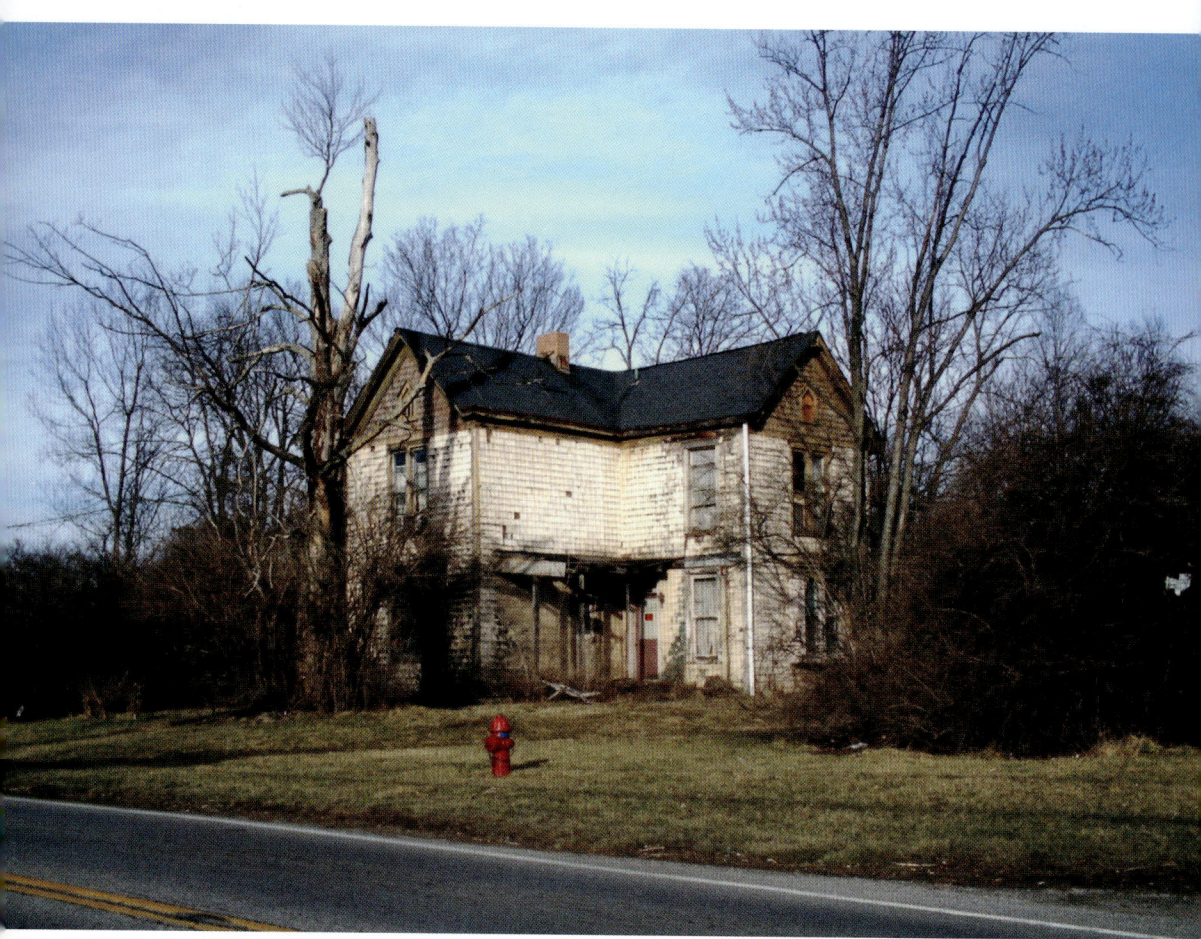

Mt. Carmel House, GPS Coordinates: 39.096724 -84.300292

Mt. Carmel, Ohio (Clermont County) — Classification: small town
An abandoned house built in 1924 next to Mount Carmel Tobasco Road sat just about a hundred feet from the town's train station on the Cincinnati, Georgetown, and Portsmouth Railroad. It shows some ornate details of architecture during the early twentieth century. The house has gone unused the last few decades and its future is uncertain. Hopefully someone who has the time and money to do a restoration will buy the place before it's considered to be financially beyond repair.

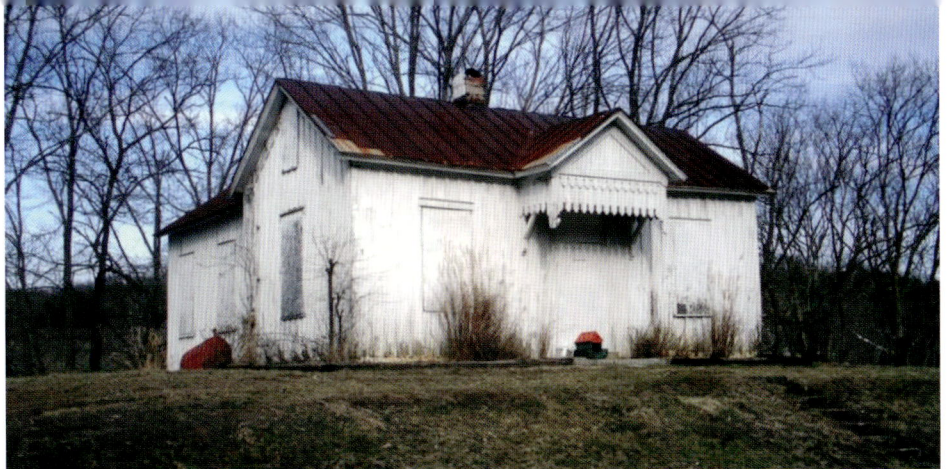

Perintown Cahoon Train Station Attendant's House, GPS Coordinates: 39.136484 -84.239927

PERINTOWN, OHIO (CLERMONT COUNTY) — CLASSIFICATION: SMALL TOWN

Cahoon train station in Perintown was named after the family of the land owner, Olive A. Cahoon (1846-1914). It stood at the railroad track bend next to Roundbottom Road on the west side of the East Fork of the Little Miami River where the attendant's house maintains its lengthy existence. The station was on the Cincinnati, Portsmouth, & Virginia Railroad (now Norfolk & Western) and later changed its name to Perintown to avoid confusing travelers and railroad workers.

Perintown was founded by War of 1812 veteran Samuel Perin (1785-1865) and Mary (Simpkins) Perin (1789-1851) in 1815 and was originally called Perins Mills. The Perins had nine children, amassed a fine 1500-acre farm, built a couple of mills, a whiskey distillery, and owned a chain of grocery stores. Samuel and Mary were buried with relatives in Perintown United Methodist Church Cemetery on US Route 50. Remains of the first power plant in the county, constructed in 1906, are on the west side of Binning Road off of Roundbottom Rd.

Perintown United Methodist Church Cemetery, GPS Coordinates: 39.137113 -84.236137

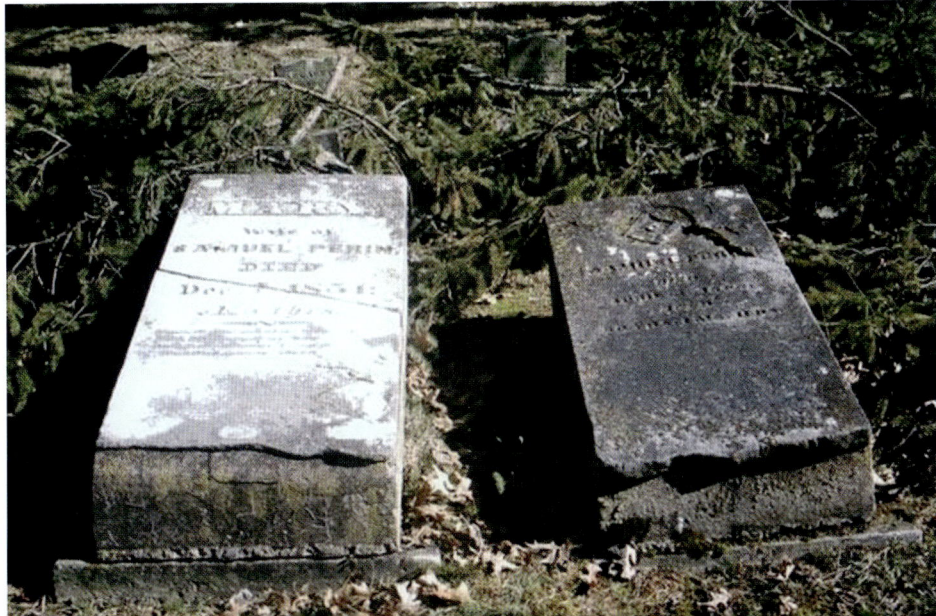

37

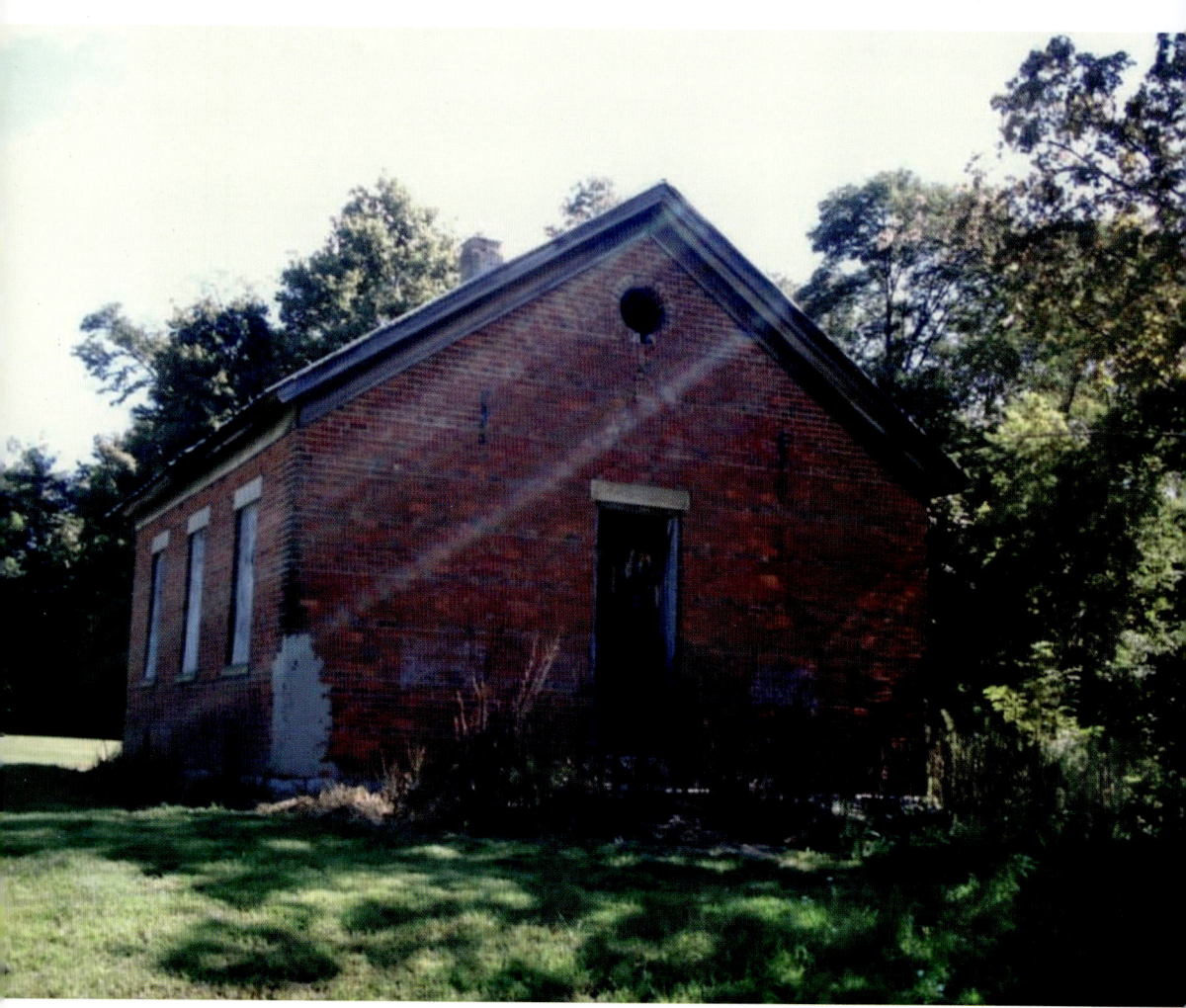

Point Pleasant School, GPS Coordinates: 38.880661 -84.195399

POINT PLEASANT, OHIO (CLERMONT COUNTY) — CLASSIFICATION: HISTORIC TOWN
Founded in 1813, Point Pleasant is best known for being the birthplace of American Civil War General and former US President Ulysses S. Grant. There are numerous historical markers around the town and Grant's birthplace home is open for tours. No matter how historic a place may be, we also recommend going off the beaten path and exploring the outskirts. An abandoned late 1800s school is on State Route 756 southeast of town.

Spann General Store, GPS Coordinates: 39.009228 -84.260255

SPANN, OHIO (CLERMONT COUNTY) — CLASSIFICATION: GHOST TOWN

This crossroads ghost town formed around a church congregation that was organized in 1802 with a small stone chapel. Originally called Ten Mile, it had to expand to accommodate the local population and formed another congregation in what would become the town of Lindale. Near the intersection of 10 Mile Road and Cole Road, Spann had a public water well that attracted travelers and a general store built in 1860 ran for a few decades. There is also a historical marker on Cole Road across from the store.

Pierce Township School #10, also known as the Corner School, peacefully sits abandoned at the intersection of Merwin 10 Mile Road and Cole Road. Spann lost its post office in 1905 and its town status shortly later in the early 1900s. Pioneers and residents were buried in Ten Mile Cemetery on Bristol Road south of 10 Mile Road. The stone chapel was next to the cemetery but has since been lost to time and nature.

Spann Corner School, GPS Coordinates: 39.013757 -84.252635

Stonelick St. Philomena Bridge, GPS Coordinates: 39.128314 -84.186111

STONELICK, OHIO (CLERMONT COUNTY) — CLASSIFICATION: SMALL TOWN

Stonelick doesn't have any businesses these days but was an important mill and farming town in the 1800s. The first Catholic congregation in the county was formed in 1839 where St. Philomena Church now stands on Balzhiser Road off of Stonelick Williams Corner Road. It was built in 1905 on the same spot as the congregation's previous churches and is still in operation. St. Philomena Church Bridge is across the road and was abandoned in 2002.

The iron bridge was constructed in 1904 by the Champion Bridge Company of Wilmington, Ohio. It was moved to its present location crossing Stonelick Creek in 1950. A dedication plaque on its west side is readable despite the peeling paint and thick rust and lists the names of commissioners and engineers who were involved in the move. The bridge is in good shape for walking across and much safer to explore than some of the others in this book.

Sabina Antique Store, GPS Coordinates: 39.496330 -83.593966

Sabina, Ohio (Clinton County) — Classification: historic town

Platted in 1830 by Warren Sabin, Sabina quickly grew with two stores, two taverns, and great farmland surrounding the village. Sabina did well through the 1800s and most of the 1900s but has struggled in recent decades and aging abandoned buildings are currently increasing in numbers. The abandoned antique shop on US Route 22 east of town has a lot of character and was open at least into the 1970s.

A two-room school north of town on Peele Road was abandoned around the time a news story put Sabina in the national spotlight in 1928. A man believed to be from Cincinnati was found dead of natural causes not far outside of town. Attempts to get in contact with anyone who could identify him failed and he was embalmed and laid out on a couch in a small building behind a local funeral home for viewing until 1964. Over a million people from all around the world visited for a look but no one could ever identify him. Named "Eugene" by the citizens of Sabina, he was finally buried in the town cemetery.

Sabina Peele Two Room School, GPS Coordinates: 39.538760 -83.665507

Sabina Richland Township #1 School, GPS Coordinates: 39.518500 -83.619809

The former Richland Township School #1 is on State Route 729 at the intersection of Roshon Road on the north side of town. Some of the children who attended the school must have had to walk a long way to get there, if they weren't lucky enough to hitch a ride on a wagon headed in that direction. The bells in abandoned schools were usually reused in new schools and other public buildings or sold for scrap.

Another one-room schoolhouse near Sabina is Sub District #2, built in 1890 on the west side of Starbuck Road south of its intersection with Sabina Road. It looks like a tank rolled through the front of the building but that surely wasn't the case. We suspect some of the bricks may have been used to make small structures at local farms. The giant hole is certainly way beyond the normal wear and tear buildings endure with Ohio's weather.

Sabina Starbuck School, GPS Coordinates: 39.525711 -83.771106

Brock Town Hall, GPS Coordinates: 40.266516 -84.558818

BROCK, OHIO (DARKE COUNTY) — CLASSIFICATION: SMALL TOWN

Brock's biggest claim to fame is being the final resting place of sharpshooter and exhibitionist Annie Oakley. Born Phoebe Ann Moses (1860-1926), Annie became one of America's most recognized entertainers and worked for "Buffalo Bill's Wild West" traveling show from 1885-1901. Meanwhile, Brock never had much more than a school, church, general store, and it's now-abandoned town hall at the intersection of State Route 185 and Greenville St. Mary's Road.

Some of the town's pioneers were buried in Old Brock (Boyd) Cemetery on the east side of US Route 127 north of State Route 185. The population was around 100 in 1880 and Brock probably doesn't have many more citizens than that today. There are no businesses and it's in danger of becoming a semi-ghost town in the future. The current number of maintained residences and lack of a larger town in the vicinity to overtake it are all that keep it in existence.

Old Brock (Boyd) Cemetery, GPS Coordinates: 40.268953 -84.570431

"New" Brock Cemetery, GPS Coordinates: 40.260172 -84.561290

Annie Oakley and her husband Frank Butler (1850-1926), who worked alongside her in the traveling entertainment business, are buried in New Brock Cemetery on Greenville St. Mary's Road south of State Route 185. The cemetery and graves are well taken care of and Annie and Frank get just as much or maybe even more attention after death than they did in life. The Garst Museum in Greenville, Ohio features exhibits about them and the town holds an annual Annie Oakley Festival.

There are also several other historical markers around Darke County which honor Annie's memory. A plaque near the site of her birthplace home was set in a large stone on the east side of Spencer Road between N Star Laramie Road and Foote Road. The log cabin Annie was born in was in an area called "The Wilds". The nearby village of North Star claims to be her hometown and also has a few historical markers on the subject.

Annie Oakley Birthplace Marker, GPS Coordinates: 40.317998 -84.472533

Dawn Auction House Back Lot, GPS Coordinates: 40.212547 -84.577818

Dawn, Ohio (Darke County) — Classification: semi-ghost town

The back lot of an abandoned auction house at the intersection of US Route 127 and Greenville St. Mary's Road is what first draws an explorer's eyes to Dawn. It was constructed to look like Fort Brier, a War of 1812 local militia blockhouse. The fort's original location has been lost to time, but it is still well remembered in the area for its significance to history.

The auction house has been closed for a few decades. Lewis Johnson (1824-1862) moved to the county from his family's namesake town, Johnsons Mill in Morgan County, West Virginia. He established Johnsons Station in Darke County and operated a saw mill, later converted to a grist mill, that was powered by the first stationary steam engine in Richland Township.

Dawn Auction House, GPS Coordinates: 40.213269 -84.579443

Dawn Church, GPS Coordinates: 40.213644, -84.579452

A small church on Greenville St. Mary's Road is the last public building left in town. After Johnsons Station, it was called Eden in the mid-1850s. The post office was also named Eden in 1856. It changed to Dawn in 1857 but the train station, located on the Big Four Railroad (Cleveland, Cincinnati, Chicago, & St. Louis Railway), was called Nevada. In the late 1800s Dawn also had a forge, tile factory, general store, a two-story school, and a couple hundred citizens.

Dawn's population started dwindling away in the early 1900s as it lost the train station, several businesses, and the post office in 1935. There are a few houses along Greenville St. Mary's Road that will never be occupied again. It's sad seeing some of them, knowing their time as useful structures has come to an end, but the land will be bought again someday, and a future will grow right where some interesting history was planted.

Dawn House, GPS Coordinates: 40.215144 -84.578905

North Star School, GPS Coordinates: 40.309994 -84.570841

NORTH STAR, OHIO (DARKE COUNTY) — CLASSIFICATION: SMALL TOWN
A one-room schoolhouse sits empty at the intersection of US Route 127 and Cohee Road. It was Wabash Township #5 and served the area on the south side of North Star which had another school in town. Some pioneers and early residents were buried in Holsapple Cemetery on the west side of Ross-Medford Road northwest of the school. We also recommend going into town to check out more of its history.

Carpenters Mills Beibers Mill, GPS Coordinates: 40.230420 -83.061999

CARPENTERS MILLS, OHIO (DELAWARE COUNTY) — CLASSIFICATION: GHOST TOWN
Revolutionary War veteran Nathan Carpenter built a saw and grist mill along the banks of the Olentangy River in 1801. It prompted more settlers to move to the area which also resulted in more mills being built next to the river that supplied sufficient power for as many as they could construct. Nathan passed away in 1814 and was buried on his family farm. Originally called Liberty Settlement, the town name changed to Carpenters Mills in the early 1830s.

One of the most successful mills was a wood frame grist mill built in 1844 on the west side of Chapman Road between US Route 23 and Winter Road. It was purchased by George Beiber and Mary (Rahn) Beiber in 1848. A stone saw mill was added in 1877 and nearly looks like a castle at first glance. The mill is a massively impressive ghost town landmark to behold next to the Olentangy River. It employed many local residents over a few decades and aided in growth of the town in the mid to late 1800s.

The grist mill is long gone but the stone saw mill does enough boasting for both. Its thick walls appear to be able to withstand at least a couple more decades of Ohio's weather. The chimney is amazingly intact and doesn't look like it will topple anytime soon. The roof is gone and there are no floors or anything inside. A small open window grants enough access to stick a camera through for some pictures from the outside.

All four sides of the building show signs of the heights that architecture could reach in Ohio at the time. The Roman style arches on the windows and door are nicely decorative and give it an almost medieval look. George and Mary's sons James Beiber (1830-1905) and Henry Beiber (1835-1917) took over mill production after their father passed away. It eventually closed with the brothers unable to keep up with payments on the debt they owed for saw mill expansion.

Added to the National Register of Historic Places in 1994, the Crist Tavern Annex-Millworkers Boarding House was built in 1835 on State Route 315 (Olentangy River Road). The hotel made life much more enjoyable for journeying apprentices and millworkers who otherwise would have had to quickly make living arrangements elsewhere in the vicinity. It also offered an ability to socialize more with the community and ride with groups of workers to job sites for an easy commute.

Carpenters Mills Crist Tavern, GPS Coordinates: 40.255379 -83.063457

New Burlington Historical Marker, GPS Coordinates: 39.567662 -83.967005

NEW BURLINGTON, OHIO (CLINTON COUNTY) — CLASSIFICATION: SMALL TOWN
Although New Burlington is still on the maps and has residents, it's considered to be a partial ghost town. Aaron Jenkins (1750-1807) arrived in Ohio from Tennessee in 1799 and founded New Burlington in 1803. He also donated the land for the cemetery and was the first person buried there. The town flourished next to Caesars Creek with a few mills, churches, grocery stores, a school, and a train station on the Grasshopper Railroad. A historical marker for New Burlington is on the east side of State Route 380, north of its intersection with New Burlington Road.

New Burlington Steps, GPS Coordinates: 39.568404 -83.966304

The older and commercial section of town was along its former main street, now an unmarked gravel road on the east side of State Route 380, north of the town's historical marker. This gravel road turns south, parallel to State Route 380, into Caesars Creek State Park and the first noticeable remnant of the past is a set of concrete steps that don't go anywhere anymore, across from where the town's last grocery store was. The area was abandoned in the early 1970s, shortly before Caesar Creek Lake was constructed, in fear of it flooding that part of town.

New Burlington's Main Street Bridge is the next remnant along the road. It's still open to traffic but will need to be heavily maintained or replaced in the near future. There's a parking spot for fishing at the end of the bridge and a former town's side street leads to Caesars Creek. Less noticeable traces of the past can be found along the trails in the area, including bricks from buildings and small objects from former residences and businesses.

New Burlington Bridge, GPS Coordinates: 39.567622 -83.965322

Old Chillicothe Historical Marker, GPS Coordinates: 39.728695 -83.936868

Old Chillicothe, Ohio (Greene County) — Classification: ghost town

A few historical markers for the Shawnee Native American ghost town of Old Chillicothe line US Route 68 in current-day Oldtown, Ohio. It was settled in 1774 along the Little Miami River and grew to be one of the Shawnee's most important towns in the state. Chief Tecumseh was raised there and rightfully sought revenge for his nation's and the town's destruction as settlers moved further west from the colonies after the Revolutionary War.

Goes Station Business, GPS Coordinates: 39.764428 -83.918060

Goes Station, Ohio (Greene County) — Classification: small town

In 1811, Revolutionary War veteran Samuel Goe (1767-1815) and Alice (Van Horn) Goe (1766-1849) settled in Greene County after leaving Pennsylvania on flatboats a couple of years earlier. They were parents to six children and founded Goes Station on their pioneer farm along the Little Miami River. It had a grist mill, saw mill, school, church, gunpowder plant, and a train station on the Little Miami Railroad. An abandoned storefront on US Route 68 was one of the last merchant shops in town.

The gunpowder plant opened in 1825 and went by the names Kings Powder Mills, Aetna Explosive Company, and the Miami Powder Company. It was remodeled and expanded a few times over the decades. The abandoned buildings left from the facility on the east side of US Route 68 along the Little Miami Scenic Trail were likely constructed in the 1860s. Samuel and Alice Goe were buried with relatives in Stevenson (Massies Creek) Cemetery on the south side of Jones Road between Wilberforce and Goes Station.

Goes Station Gunpowder Plant, GPS Coordinates: 39.761315 -83.920805

Kimbolton McCleary Cemetery, GPS Coordinates: 40.126570 -81.510098

KIMBOLTON, OHIO (GUERNSEY COUNTY) — CLASSIFICATION: SMALL TOWN
McCleary Cemetery off of Road 4 in Salt Fork State Park was established by the McCleary family who owned a grist mill and saw mill on their farm. Over 200 local citizens were laid to rest at the spot that thankfully was spared by Salt Fork Lake when it was constructed. Old homestead foundations and other structures from the area's past can be spotted close to the lake bank.

Dent School, GPS Coordinates: 39.177351 -84.645103

DENT, OHIO (HAMILTON COUNTY) — CLASSIFICATION: SMALL TOWN
The Dent Schoolhouse on Harrison Avenue was built in 1894 and closed in 1950. It's reportedly haunted by the ghost of Charlie McFree, a former janitor who was accused of killing school children and stuffing their bodies in the walls of the basement. This more than exaggerated story has never been confirmed but helps draw in visitors during Halloween season. Averaging over 30,000 ticket sales every year, The Dent Schoolhouse is one of the most popular Halloween attractions in Ohio.

Columbia, Tusculum Toy Store, GPS Coordinates: 39.117848 -84.442202

COLUMBIA-TUSCULUM, OHIO (HAMILTON COUNTY) – CLASSIFICATION: HISTORIC TOWN
An abandoned toy store on US Route 52 was in operation into the 1990s. The building was constructed in 1869 and sits empty along with many other historic businesses and residences in Columbia-Tusculum. Originally named Columbia, it was the first town in Hamilton County and was founded in 1788 by Revolutionary War veteran Major Benjamin Stites (1734-1804) who owned 20,000 acres of land in the vicinity. A group of twenty-six settlers traveled with him on the journey down the Ohio River from Pennsylvania to the future town site.

Columbia grew rapidly and became an important transportation hub in the mid-1800s to mid-1900s. On top of its location at the confluence of the Little Miami and the Ohio Rivers, the town attracted a train station on the Little Miami Railroad in 1841, another on the Cincinnati, Georgetown, & Portsmouth Railroad in 1877, and cable cars operated by the Columbia Street Railway started rolling in 1890. Artwork lingers on a retaining wall at the abandoned Torrence Road train station between US Route 52 and US Route 50 that served the public from 1907-1933.

Columbia, Tusculum Train Station Wall Art, GPS Coordinates: 39.124567 -84.461857

Columbia, Tusculum Pioneer Cemetery, GPS Coordinates: 39.105914 -84.428725

By 1900, Columbia started going by the name East End, which referred to its location on the eastern edge of Cincinnati. Lunken Airport was built in 1925 on the south side of Columbia, adding yet another transportation industry to the town. The local economy held steady through the mid-1900s but started declining after that. Benjamin Stites was buried with relatives in Pioneer (Columbia Baptist Church) Cemetery on Wilmer Avenue across from the airport.

The cemetery is well maintained, neat to explore, and has many historical markers dedicated to the town's early residents. The base of a tall monument constructed by Columbia's first church congregation has engraved info on all four sides including the names of Columbia's twenty-six original settlers. It's a peaceful and relatively quiet location that seems a world away from the rush of city life right outside the cemetery boundaries.

McClure Radish Packing Plant, GPS Coordinates: 41.356840 -83.941373

MCCLURE, OHIO (HENRY COUNTY) — CLASSIFICATION: SMALL TOWN
John McClure (1824-1914) and Mary (Beaver) McClure (1837-1915) platted the town in 1880 on the Toledo, St. Louis, & Western Railroad. It was the last place in Ohio to use the manual telephone system with switchboard operators relaying the calls. An abandoned radish packing plant at the intersection of State Route 65 and Township Road N south of town has seen better days and a reduction of farming in the area. John and Mary McClure were buried in Hockman Cemetery on Township Highway 4 in town.

Westhope House, GPS Coordinates: 41.278354 -83.940670

WESTHOPE, OHIO (HENRY COUNTY) — CLASSIFICATION: SMALL TOWN
Westhope was never platted and didn't have any major businesses besides farming. It only found its way onto maps due to having a general store, church, and a post office from 1869-1919. The church is still in operation and is the only public building. An abandoned house next to State Route 65 between State Route 281 and County Road H1 has a very historic look and hopefully will be restored someday.

Barretts Mill, GPS Coordinates: 39.202349 -83.387638

BARRETTS MILLS, OHIO (HIGHLAND COUNTY) — CLASSIFICATION: SMALL TOWN
Factory Branch Creek supplied power for a saw mill, grist mill, and wool mill in the early 1800s. One of the mills was purchased by David Barrett (1829-1909) in 1858 and the town was subsequently named after him. David enlisted in the Union Army during the American Civil War and achieved the rank of captain. What's left of the mill on Cave Road is across Factory Branch Creek from Barrett Mill Road and sits next to a hand-built stone dam. Trestles from a covered bridge that once crossed the creek to the wood frame mill with a stone foundation remain intact.

The mill doesn't have any floors left inside but an axle with gears that was turned by the waterwheel sticks out from its foundation. After the mills closed and the town lost its post office that ran from 1885-1907, it didn't get any new major businesses and the population declined some. Newer residences are spread around the area with no village anymore. The dam on Factory Branch Creek makes a good fishing spot with easy access from the Barrett Mill Road side.

Fallsville Lane, GPS Coordinates: 39.285764 -83.631047

FALLSVILLE, OHIO (HIGHLAND COUNTY) — CLASSIFICATION: GHOST TOWN
John Timberlake built a house and grist mill next to the waterfall on Clear Creek, both of which were purchased in 1825 by Simon Clouser (1796-1881) and Elizabeth Clouser (1797-1875). The Clousers were farmers and operated the grist mill which became relatively popular as it was the only one for miles in any direction. The town was platted by John Timberlake in 1848 and had eight houses on three streets. The main street, Fallsville Lane, is now closed from traffic with parking at its entrance on Careytown Road for access back to the Fallsville Wildlife Area.

Fallsville Auburn Methodist Church, GPS Coordinates: 39.292444 -83.631382

Residents and town promoters assumed Fallsville would attract a railroad, get a train station, and sort of live happily ever after. That never happened and Fallsville was left in the dust along with many others around the state while trying to compete with towns that had railroads, canals, or major waterways. Auburn Methodist Church was constructed on Careytown Road north of Fallsville Lane in 1891, just two years before the town's last resident passed away in 1893.

Simon and Elizabeth Clouser were buried with their children in the church cemetery. Remnants of the town are scattered around the woods at the end of Fallsville Lane. There are a few house foundations and a rusting water tank for horses, from the days before motorized transportation, where Fallsville's residential section stood to the south of where the gravel on Fallsville Lane ends. The waterfall is along the trail straight past the end of the gravel road.

McCoppin Mill, GPS Coordinates: 39.182769 -83.437384

MCCOPPIN MILL, OHIO (HIGHLAND COUNTY) — CLASSIFICATION: SMALL TOWN

Another amazing hand-built stone dam in the county crosses Rocky Fork Creek on the north side of McCoppin Mill Road. David Reece was the first settler and constructed a saw and grist mill in 1829. Thomas Costello (1853-1906) purchased the mill in the late 1890s and changed the town name to Lodores with a post office from 1898-1903. He was unfortunately found dead in Rocky Fork Creek near the mill after a machinery accident.

Later that same year, John McCoppin (1847-1931) and Ann (Foraker) McCoppin (1848-1928) bought the mill and became the town's namesakes. They remodeled it and the ownership changed a few more times before production stopped in 1979. The dam and mill are on private property, but there are places to park near the bridge crossing Rocky Fork Creek on McCoppin Mill road. It's at least a neat historic location to stop by and get some pictures.

Centerburg Train Station, GPS Coordinates: 40.298617 -82.704633

Centerburg, Ohio (Knox County) — Classification: historic town

Founded in 1834 at the geographical center of Ohio, Centerburg quickly grew and became an important railroad town. There are numerous historic buildings and markers in Centerburg and its abandoned train station from the Toledo & Ohio Central Railroad is on US Route 36 on the south side of town next to its former track bed. The Heart of Ohio Recreational Trail passes through Centerburg along the former track bed of the Cleveland, Akron, & Columbus Railroad.

Olive Furnace, GPS Coordinates: 38.762766 -82.629716

OLIVE FURNACE, OHIO (LAWRENCE COUNTY) — CLASSIFICATION: SEMI-GHOST TOWN
Remains of the Olive Furnace are next to Olive Creek on the west side of State Route 93. It was constructed in 1846 and provided steel for Union troops and railroads during the American Civil War. On top of providing jobs to the town's citizens, the furnace company owned 3,600 acres of land and most of the early roads in the township were built and maintained by its labor force. Farming also added to the local economy.

The most outstanding feature of the furnace is its Roman style arch which appears to still hold strong after over 170 years of enduring Ohio's weather. Foundation and wall blocks left from the engine house are scattered about the hill next to the furnace. The town was occasionally referred to as Mt. Olive and also had a general store, school, blacksmith shop, hardware store, and a post office. Its train station on the Cincinnati, Hamilton, & Dayton Railroad was about a half mile south of town.

Olive Furnace produced an average of 4,000 tons of iron every year and supplied steel factories in Ohio as well as around the country until production stopped in 1910. It was sold and dismantled in 1915, likely used for a scrap metal drive during mobilization efforts in World War I. Smokestacks on Ohio's 1800s furnaces were generally between twenty and one hundred feet tall and were also dismantled as common practice when their time as profitable businesses came to an end.

Mount Olive Community Baptist Church on State Route 93 across from the furnace site is the last public building left in town. Some of the mining workers and other residents were buried in Olive Furnace Cemetery up the hill on an unnamed gravel road behind the furnace. There are plans to eventually restore the furnace and donations are currently being accepted by the Mt. Olive Furnace Park Corporation.

Lock General Store, GPS Coordinates: 40.271114 -82.610945

LOCK, OHIO (LICKING COUNTY) — CLASSIFICATION: SEMI-GHOST TOWN
An abandoned general store on the Licking and Knox County border at the intersection of State Route 657 and Lock Road was the last business in town and has been closed for a few decades. The first business was an ashery run by Isham Abbott (1799-1859) who laid out lots for Lock in 1837 and later moved to Indiana with his family. The 1870s were the town's heyday with two stores, a warehouse, cooper shop, wagon shop, three churches, and a few other merchant shops.

Across the street from the general store, the Congregational Church built in 1844 was also used as a community meeting hall. Although it needs some work, the structure is in excellent shape for its age and there are not many wood frame churches around Ohio that old. Lock never had any large industries to create a population boom in the late 1800s or 1900s. There are a couple of abandoned houses in town and Lock Cemetery is on State Route 657 south of Lock Road.

Washington Hildreth (1829-1903) was the most well-known citizen laid to rest in the cemetery, an entrepreneur who owned several lots in town including the stores and warehouse. He was Lock's last postmaster, a member of the Ohio National Guard, and joined the Order of Good Templars which assembled at a meeting house on Washington's property called Hildreth's Hall.

Lock Cemetery, GPS Coordinates:
40.268697 -82.608437

San Toy Jail, GPS Coordinates: 39.637256 -82.034796

SAN TOY, OHIO (PERRY COUNTY) — CLASSIFICATION: SEMI-GHOST TOWN
The Sunday Creek Coal Company built San Toy in 1900 to house and accommodate its workers. This rough and rowdy mining town at the northern edge of Ohio's Hanging Rock Region had a roller coaster's worth of ups and downs. San Toy boomed from the very beginning and made its best attempt to maintain law and order in a densely populated community. The town's jail at the southwest corner of the intersection of Santoy Road and Township Highway 452 hides out in a wooded lot these days and appears to enjoy the peace and quiet.

Across Santoy Road from the jail, a water well pump house has lost its roof, but the walls are still intact. The town's tough reputation was partly due to its large number of saloons and drinking being the biggest after-work hobby. San Toy had the only hospital in the county at the time and needed it for both for the mine workers and those injured in bar brawls and street fights. It also had a theater and a baseball team for entertainment. The baseball team competed against other mining company and small-town teams in the area.

San Toy Water Pump House, GPS Coordinates: 39.637472 -82.035249

San Toy Steps, GPS Coordinates: 39.637309 -82.034914

In 1924 a group of disgruntled workers pushed a cart full of flaming logs down into a mine shaft during a labor dispute. The fire destroyed the mine, hospital, and theater. After the dispute was settled, mining continued until 1927 when the coal company decided it didn't want to invest in the location anymore. Instantly losing their main industry, San Toy's citizens didn't have many other options and most moved away as soon as possible. Another set of steps that don't go anywhere anymore climbs into oblivion where a house used to be near the jail.

The few residents that stayed behind kept the town going with revenue from making moonshine. Between 1927 and 1930 San Toy lost more residents than any other town in the United States. Seventeen of its nineteen remaining citizens voted to abandon the town in 1931. There are now newer residences in the area among the remnants of the ghost town and it still goes by the name San Toy. Sweeping back some gravel on San Toy Road, the old brick road from the town's heyday gets another glimpse of sunlight in the present as it hangs onto memories of the town's past.

San Toy Brick Road, GPS Coordinates: 39.637549 -82.034878

Fairhaven Bunker Hill House, GPS Coordinates: 39.637072 -84.771955

FAIRHAVEN, OHIO (PREBLE COUNTY) — CLASSIFICATION: SMALL TOWN
Founded in the early 1830s, Fairhaven is home to the Bunker Hill House on State Route 177 which was an important stagecoach stop on the Hamilton, Fairhaven, and Richmond Turnpike and is one of the most impressive historic landmarks in Ohio. Construction took place from 1834-1838. One look is all it takes and it's easy to see why weary visitors would have been enticed to the massive structure. It served as a hotel and had a tavern until 1858 when a railroad built through nearby Camden took travelers past Fairhaven.

In 1862 the Bunker Hill House expanded with a general store. Local resident Gabriel Smith was a member of the Freedom of Friends Society and helped runaway slaves escape further north during the American Civil War era. He lived at the Bunker Hill House for a while and occasionally hid slaves in his room under a stairway next to the servant's quarters. Gabriel was buried in Fairhaven Cemetery on Israel Somers Road. The Bunker Hill House was added to the National Register of Historic Places in 2001.

The town demolished some of its abandoned buildings and houses in the last few years but it's still on the verge of becoming a semi-ghost town due to its population decrease since its peak and the potential for more buildings to be abandoned in the future. On the outskirts of Fairhaven, a late-1800s one-room schoolhouse at the intersection of California School Road and Toney Lybrook Road served students in the rural area northwest of the village.

Fairhaven School, GPS Coordinates: 39.699816 -84.797932

Wheatville, Eikenberry Cemetery, GPS Coordinates: 39.685371 -84.575287

WHEATVILLE, OHIO (PREBLE COUNTY) — CLASSIFICATION: SMALL TOWN
Eikenberry-Wheatville Cemetery on the east side of Quaker Trace Road south of State Route 122 stares across Auckerman Creek to the vast plains of Preble County. The first settlers in Wheatville were Henry Eikenberry (1771-1828) and Mary (Landis) Eikenberry (1772-1868) who moved to Ohio from Virginia in 1807. They had seven children and the last was born after the family relocated. The town was named after its flour mills.

In the 1870s, Wheatville had a steam saw mill, school, and a church. Farming has always been the main industry. The center of town is at the crossroads of State Route 122 and Quaker Trace Road. There are no records of any attempts to plat a village and residences stretch out along the roads leading away from the main intersection. Henry and Mary Eikenberry were buried with relatives and local pioneers in Eikenberry-Wheatville Cemetery.

Lanier Township #7, the name of an old school, was built in 1889 northeast of town on Halderman Road between Quaker Trace Road and State Route 503. Another former school, Lanier Township #9, was constructed in 1896 at the corner of Quaker Trace Road and Auckerman Creek Road on the south side of town. Many of the 1800s one-room schoolhouses in the county are maintained and used for storage.

Wheatville Lanier Township #7 School, GPS Coordinates: 39.707850 -84.556238

Belmore Town Hall, GPS Coordinates: 41.153951 -83.940963

BELMORE, OHIO (PUTNAM COUNTY) — CLASSIFICATION: SEMI-GHOST TOWN
Abandoned town halls are a common sight in semi-ghost towns, where they were rendered obsolete as populations drastically declined. The Belmore town hall was constructed in 1908 on Main Street west of State Route 65. Platted as Montgomeryville in 1862 by Wesley Montgomery (1813-1892), the name changed in 1868 to match its post office. Belmore expanded with a train station on the Cincinnati, Hamilton, & Dayton Railroad in 1869 and business began to boom.

The flourishing town had a mill, hotel, a couple of grocery stores, and several smaller businesses in the 1870s. Belmore's population peaked in the 1880s with approximately 450 citizens and its success continued well into the 1900s. A new school was built in 1904 and the town got a bank in 1907. Things, of course, can change a lot over 100 years or so and a former business across the street from the town hall gets overtaken by nature a little bit more every year.

Belmore's steam was running out and no major businesses moved into the area in the mid-1900s as the old industries were closing their doors. Its last church, just up the road from the town hall on Main Street also sits abandoned. The current population is around 120 residents. There are a few other abandoned businesses and houses around town worth checking out, clinging onto their history with an uncertain future. Belmore's cemeteries are on Road Y, one on the east side of town and another on the west side.

Belmore Church, GPS Coordinates: 41.153684 -83.939881

Leipsic School, GPS Coordinates: 41.123986 -83.938418

LEIPSIC, OHIO (PUTNAM COUNTY) — CLASSIFICATION: SMALL TOWN
Leipsic was founded in 1857 and maintains a population of over 2,000. Some of Belmore's former residents were also buried in Sugar Ridge Cemetery and the adjoining Sugar Ridge Van Buren Cemetery on State Route 613 in Leipsic. At the intersection of State Route 65 and Township Road D, a one-room schoolhouse served rural residents near Little Yellow Creek northeast of town.

Riblet Cemetery, GPS Coordinates: 40.761289 -82.688615

RIBLET, OHIO (RICHLAND COUNTY) — CLASSIFICATION: GHOST TOWN
Revolutionary War veteran Christian Riblet (1761-1844) and Christina (Shull) Riblet (1763-1852) arrived in Richland County from Pennsylvania in 1831. They had four children and a prosperous farm that turned into a stagecoach stop between Mansfield and Bucyrus. It had a tavern and post office that ran from 1836-1860. Riblet Cemetery on the south side of State Route 309 between County Highway 175 and State Route 181 is the only intact remnant from the town.

Harper School, GPS Coordinates: 39.355789 -83.268487

HARPER, OHIO (ROSS COUNTY) — CLASSIFICATION: SMALL TOWN

A one-room school on State Route 28 at the intersection Morgan Road was built in 1868 and is well maintained. The town was named after the Harper family who donated land for a train station on the Marietta & Cincinnati Railroad. It had a post office from 1867-1927 but was never platted or incorporated. Early residents were buried in Harper Cemetery on the north side of Harper Station Road above the abandoned railroad track bed.

Storms Shoults Cemetery, GPS Coordinates: 39.249497 -83.168075

STORMS, OHIO (ROSS COUNTY) — CLASSIFICATION: SMALL TOWN

Shoults Cemetery on Spargursville Nipgen Road was established in the early 1800s on land originally owned by War of 1812 veteran John Storm (1790-1889) and Diana (DeHart) Storm (1796-1866). They both moved to Ohio from Virginia at young ages with their families. Their daughter Elizabeth and her husband James Shoults inherited the land. They were all buried in Storms Cemetery on the west side of Spargursville Nipgen Road south of Sulphur Lick.

The Storm family donated land for a train station on the Dayton, Toledo, & Ironton Railroad. The town also had a grain elevator, general store, and a post office from 1887-1940. Farming was the main industry, but citizens also practiced a myriad of other crafts, such as blacksmith work and cabinet making. Storms Chapel on Spargursville Nipgen Road was built in 1897. It's the last public building left in town and is still in operation.

Storms Chapel, GPS Coordinates: 39.231873 -83.170231

81

Boston Cemetery, GPS Coordinates: 41.266391 -81.560220

BOSTON MILLS, OHIO (SUMMIT COUNTY) – CLASSIFICATION: GHOST TOWN
Boston Mills was founded in 1806 by surveyors from Connecticut who built a cabin on the grounds of what would later become Boston Cemetery and boomed early on when the Ohio & Erie Canal opened in 1827. It was named after Boston, Massachusetts, as was the township it's in. There were many mills in the area including a saw mill and a paper mill owned by the Cleveland-Akron Bag Company. The reportedly haunted Boston Cemetery on Main Street is one of the area's biggest attractions.

Boston Mills kept growing through the late 1800s and early 1900s but lost its town status in 1974 when the land was designated as a national recreation area and became part of the Cuyahoga Valley National Park. Many residents were forced out by eminent domain and their houses were subsequently demolished. The Boston Mills Community Church and several other old buildings on the south side of town were spared. Some were used as practice for local fire departments and the strange sight of the aftermath resulted in Boston Mills getting the nickname "Helltown".

Boston Mills Community Church, GPS Coordinates: 41.264520 -81.555956

Boston Mills M.D. Garage, GPS Coordinates: 41.263395 -81.558821

Remaining residents are proud of their past and there are a few restored buildings around town. A former gas and service station on Boston Mills Road shows what they were like in the 1940s-1960s. The train station in Peninsula suffered heavy damage in the Great Flood of 1913 but has been restored and moved to the intersection of County Road 9 and Boston Mills Road. It currently serves the Cuyahoga Valley Scenic Railroad.

A "crybaby bridge" leading into town on Boston Mills Road around the corner from the train station crosses the Cuyahoga River. It basically has the same urban legend as the hundreds of other bridges around the country with the nickname and no historical evidence to support the tale. The "End of the World" is the nickname given to the location where Stanford Road comes to an abrupt close on the northeast side of town. The ghost town of Brandywine Village is on the other side.

Boston Mills Crybaby Bridge, GPS Coordinates: 41.262903 -81.560141

Brandywine Falls, GPS Coordinates: 41.276743 -81.538964

BRANDYWINE VILLAGE, OHIO (SUMMIT COUNTY) — CLASSIFICATION: GHOST TOWN
An awesome waterfall on Brandywine Road witnessed the rise and fall of a once prosperous town. George Wallace (1771-1849) and Harriet (Menough) Wallace (1784-1848) arrived in 1814 and built a cabin next to the creek that Harriet named Brandywine. They constructed a saw mill, grist mill, wool mill and a whiskey distillery by 1821. Their whiskey was affectionately called "Brandywine Currency," and was used for trade in the days before paper money was commonly used.

The Wallace's children inherited the family's 1200-acre farm and the mills. Despite its good growth, Brandywine got passed up by the Ohio & Erie Canal and local railroads. The mills were abandoned before 1900 and the village started declining. The last business in town was the Champion Electric Company which manufactured restaurant appliances. It was built on the site of the old mills next to the falls in 1920 and destroyed by a lightning fire in 1937. The creek has a nice boardwalk along the falls and a picnic area next to the parking lot on Brandywine Road.

Irwin School, GPS Coordinates: 40.124149 -83.491830

Irwin, Ohio (Union County) — Classification: small town

One of the coolest abandoned schools in Ohio is at the intersection of State Route 161 and State Route 4 in Irwin. It was constructed in 1903 and closed in 1939, unable to be updated to meet building codes at the time. The town was founded by John Irwin (1762-1830) and Anna (Steel) Irwin (1764-1854) who moved to Ohio from Pennsylvania. It had a train station on the Big Four Railroad. Business has declined since the early 1900s, but Irwin still has a post office and steadily maintains its population.

Hope Furance, GPS Coordinates: 39.331940 -82.340422

Hope, Ohio (Vinton County) — Classification: small town

The most recognized landmark in Hope is its iron furnace on State Route 278 close to the edge of Lake Hope. It was in operation from 1854-1875 and is supposedly haunted by the ghost of a watchman who fell to his death inside. Reports state he can occasionally be seen on stormy nights making his rounds with a lantern. The town had a train station on the Big Sand Railroad (later bought by the B&O), a large rail yard for the local mining industry, a general store, school, church, and some small businesses.

Hope hit its peak population around 1870 with 300 citizens which greatly reduced when furnace production and mining came to a grinding halt. The town lost its post office in 1890 and nearly became a ghost town in the late 1930s when construction of Lake Hope was completed. Much of the old town ended up inundated by its waters. The furnace was listed on the National Register of Historic Places in 1973.

Moonville Tunnel, GPS Coordinates: 39.307455 -82.322796

MOONVILLE, OHIO (VINTON COUNTY) — CLASSIFICATION: GHOST TOWN
Currently the most popular ghost town in the state, Moonville gets thousands of visitors every year and won't be knocked out of the top spot anytime soon. Its main attraction is an abandoned railroad tunnel on the former train track bed heading east from Hope-Moonville Road across Raccoon Creek. The tunnel granted access to speeding trains rolling through the area and is shrouded in local legend and folklore. It's believed by many to be one of the most haunted locations in Ohio.

The town is said to have been named after a Mr. Moon who operated a general store in the vicinity and is a bit of a mystery. Many researchers have scoured the scarce genealogy records from the time period but were unable to reveal more clues about the proprietor's exact identity. Samuel Coe (1813-1883) and Emaline (Newcomb) Coe (1817-1895) are credited with founding Moonville. They donated land for a train station on the Marietta & Cincinnati Railroad in 1856 to move coal and clay away from mines on their property. The tunnel was constructed later that year.

With no roads leading into Moonville through the rough terrain and densely forested area, walking the railroad tracks and going through the tunnel was the only option for some. Unfortunately, many confirmed deaths occurred due to residents and locals getting stuck on the trestle crossing Raccoon Creek or inside the tunnel when trains were rapidly approaching. A brakeman was reportedly crushed between train cars in the tunnel and a couple of others died from attempting to jump off trains that weren't stopping at Moonville on their commutes home from work.

Moonville Cemetery, GPS Coordinates: 39.306272 -82.324660

Moonville Cemetery is also supposedly haunted by some of the town's former citizens. It's up a steep gravel road on the west side of Hope-Moonville Road, south of the Moonville Rail Trail. Samuel and Emaline Coe were buried there with relatives. The town's population was never much more than 100 residents, so it didn't need a large cemetery. Many residents were buried back on their family farms or in cemeteries in their hometowns.

A smallpox epidemic in the 1890s created Moonville's initial population decline and mining production shut down over the next couple of decades. There weren't many residents left by the 1920s and the last family moved away in 1947. The Moonville Rail Trail Association raised funds to build bridges where train trestles were demolished as the tracks were removed in the 1980s. They also organize an annual event called "Midnight at Moonville", which celebrates the ghost town's heritage.

89

Oreton Company Store Safe, GPS Coordinates: 39.163804 -82.412769

ORETON STATION, OHIO (VINTON COUNTY) – CLASSIFICATION: GHOST TOWN
About halfway between Hamden and State Route 32, a small and unassuming structure watches modern-day traffic roll by from the north side of State Route 160. The brick safe of a mining company store was constructed in vastly different times. A gravel lot surrounding it now serves as parking for exploring the ghost town. Oreton Station sprang up with the completion of the Eagle Iron Furnace in 1852. Its toppled remains are on an unmarked gravel road on the south side of State Route 160 next to Pierces Run.

The town's train station was on the Columbus, Hocking Valley, & Toledo Railroad and had a seventeen train-car length passing siding between the tracks for loading and unloading cargo and passengers. It's still intact but constantly battling nature along the former railroad track bed trail heading west from the parking spot. Oreton Station boomed through the early 1900s with no shortage of mining and railroad jobs, about seventy houses, a school, and a church. Some of the town's buildings were constructed with Nelsonville Blocks from Athens County, which won first place at the 1904 World's Fair in St. Louis, Missouri.

Oreton Trail Remnants, GPS Coordinates: 39.164298 -82.413460

Mining was originally conducted by the New York Coal Company. The industry extracted iron, coal, shale, and small amounts of silver from the area. Some of the trails near the company store safe led to shaft entrances. They were sealed up with dirt and stones when the mines shut down in the early 1900s but are starting to open again with time and erosion. Exploring inside them is not recommended, nor at any other abandoned mines in the state for that matter. It's too dangerous and not worth the risks.

The last train rolled through the now-sealed Eagle Tunnel along the former track bed in 1930. Mining resources that fueled the local economy were exhausted and all the businesses were gone by the mid-1900s. The post office closed in 1950 and not a single soul occupied the town after the 1960s. Oreton Station didn't have a cemetery because most of the residents just moved there for work, but a few other remnants of the town's glory days can be found in the area.

Puritan Brick Plant, GPS Coordinates: 39.158121 -82.488065

PURITAN, OHIO (VINTON COUNTY) — CLASSIFICATION: SMALL TOWN
On State Route 160 along Sugar Run between Hamden and Oreton Station, this small farming town was in Ross County prior to the formation of Vinton County in 1850 and called Charleston. It became the site of Hamden Furnace in 1851 and the town took that name in 1853. The massive complex created a population boom, surpassing farming as the local main source of income. After the furnace operations ended, the Puritan Brick Plant moved onto the site.

The company began firing away in 1909, providing around 100 jobs for residents, who changed the town's name again to match its biggest business. It was one of the largest brick companies in the state and purchased 980 acres of land near Puritan. Coal mining to fuel the ovens and a shale mine for a much-needed brick and cement ingredient also added to jobs and the local economy. One of the smokestacks on the site is leaning a bit but might stay standing for years to come.

Brick making was a huge industry in Ohio during the late 1880s and early 1900s and helped turn former wagon roads into paved roads for horseless vehicles. 66,000 facing bricks or 100,000 paving bricks could be produced and stored each day. The company needed a way to haul the inventory off the property and built the Puritan Railway with over a mile of tracks going from the plant to the B&O Railroad. Part of an exposed brick oven in the complex is now a planter box for nature.

The plant was sold to the McArthur Brick Company after the World War I and operated into the early 1960s. Logging has been conducted at the site since then and it's amazing that so many relics of the past have survived. Paving and facing bricks are scattered all around from fallen structures and leftover inventory. The tallest smokestack in the complex is a head turner and you have to be pretty far away to get it all in a picture.

Puritan Cemetery, GPS Coordinates: 39.160658 -82.489527

Some of the town's citizens were buried in Puritan Cemetery at the end of Puritan Road, north of State Route 160 off of Patton Road. It started out as a family farm cemetery and the oldest recorded burial is from 1805. The top of the tallest smokestack at the brick plant can be seen from the cemetery even in summer, poking its head over the trees to keep an eye on the town.

Vinton Furnace Bridge, GPS Coordinates: 39.217581 -82.404322

VINTON FURNACE, OHIO (VINTON COUNTY) — CLASSIFICATION: GHOST TOWN
It's not nearly as popular as Moonville but making the journey to Vinton Furnace is just as cool and can feel a bit more secluded with less visitors. The remnants of the town are on hiking trails off of Stone Quarry Road. It's about three miles east of McArthur and a turn south off of US Route 50. Once on Stone Quarry Road, keep driving to a fork in the road and stay to the left. Go through a few road bends and a former county road on the right side that's now a hiking trail leads to the closed bridge crossing Elk Fork.

The trail comes to a fork after crossing the creek and going right leads to the furnace remains. It started blasting iron ore in 1854 and employed about 100 residents who were paid in company general store tokens. The furnace is in bad shape, toppled over and there's not much left, but it's still an interesting sight to explore. The town also had a row of houses for the workers and a train station on the B&O Railroad with a line of tracks called the Vinton Furnace Switch that ran to the furnace site.

A set of abandoned coke ovens are further up the trail behind the furnace. They were used to convert coal into a coke fuel for smelting iron at hotter temperatures to produce better quality. The ovens were very expensive, made in Belgium, and only installed at a few furnaces around the world. Unfortunately, they didn't work well and ended up being part of the company's and town's demise.

The furnace went out of business in 1880 but aside from losing their jobs, it wasn't a terribly devastating experience for some of the workers as it was in other towns that lasted longer. Many of them commuted to Vinton Furnace and left their families back on their home farms. The area was quickly abandoned and has been ever since. On top of the structures left from the past, Vinton Furnace's desolation makes it one of the most interesting ghost towns in the state to visit.

Kings Mills Trestle, GPS Coordinates: 39.352720 -84.241944

KINGS MILLS, OHIO (WARREN COUNTY) — CLASSIFICATION: SMALL TOWN
Founded in 1884 as a company town for the King Powder Company, Kings Mills had two train stations that served the local community. One was on the Pennsylvania Railroad and sat next to the Peters Cartridge Company which was in operation from 1887-1944. What's left of an abandoned trestle that led to the munitions facility sits in the woods on the east side of King Avenue near the Little Miami River.

Kings Mills Dog Street Cemetery, GPS Coordinates: 39.350089 -84.267796

Dog Street Cemetery was established in the 1840s and now sits on the north side of Kings Island Amusement Park off of Kings Island Drive. The earliest known owners of the land were Alexander Dill (1788-1877) and Julia (Hall) Dill (1807-1844) who started the cemetery on their family farm. It's reportedly haunted by Missouri Jane Galeenor (1840-1846) who was buried there and is also known as "Tram Girl", due to occasionally being spotted late at night by tram operators in the parking lot of the amusement park.

Later in the 1800s, the land was owned by John Hoff (1832-1899) and Mary Ann (Dill) Hoff (1834-1872). It was passed down to John D. Hoff (1863-1950) and Leila (Beedle) Hoff (1872-1942) and called the Hoff Farm Cemetery during that time. The final land holders were Mr. & Mrs. R Eugene King in the 1960s. While Paramount Pictures operated the amusement park in 1992-2006, they attempted to get the cemetery moved but failed to raise approval from descendants who have ancestors buried there.

Most of the land's former owners were buried in Rose Hill Cemetery on Mason-Montgomery Road but all of them have relatives buried in Dog Street Cemetery. There are about seventy known burials and fifty headstones remaining. It's maintained by Deerfield Township and there are ample places to park a vehicle before reaching the admission gates of the amusement park. The cemetery is certainly a serene environment and hopefully will retain its rightful place in the world and never get moved.

BIBLIOGRAPHY

County history books and maps published in the 1850s-1920s were the main resources used to compile this work. The history books contain firsthand accounts of what life was like for residents when the towns were organized and during their heydays. Smaller tidbits of information, such as genealogy and railroad records, were collected from various database style websites.

ADAMS COUNTY

Arms, Walter F. *Caldwell's Illustrated Historical Atlas of Adams County, Ohio*. J. A. Caldwell, 1880, www.historicmapworks.com/Atlas/US/11049/Adams+County+1880/.

Evans, Nelson W., And Emmons B. Stivers. *A History of Adams County, Ohio*. E. B. Stivers, 1900, books.google.com/books/about/A_History_of_Adams_County_Ohio.html?id=8HwUAAAAYAAJ.

ASHTABULA COUNTY

Lake, D. J. *Atlas of Ashtabula County, Ohio*. Titus, Simmons, & Titus, 1874, www.historicmapworks.com/Atlas/US/9691/Ashtabula+County+1874/.

Large, Moina W. *History of Ashtabula County, Ohio*. Historical Pub. Co., 1924, www.conneautohio.us/Ashtaco_ConneautHistory_v.htm.

ATHENS COUNTY

Lake, D. J. *Atlas of Athens Co., Ohio*. Titus, Simmons, & Titus, 1875, www.historicmapworks.com/Atlas/US/9772/Athens County 1875/.

Neff, Robert. "The Broadwell Family Story." *The Broadwell Family Tree*. Updated 2017, www.neff.family.name/Broadwell.html.

Walker, Charles M. *History of Athens County, Ohio*. Robert Clarke & Co., 1869, archive.org/stream/historyofathensc00walk#page/n13/mode/2up.

BELMONT COUNTY

Caldwell, J. A. *History of Belmont And Jefferson Counties, Ohio*. The Historical Publishing Company, 1880, books.google.com/books/about/History_of_Belmont_and_Jefferson_Countie.html?id=zS00QAAACAAJ.

Lathrop, J. M. and Penny, H. C. *Atlas of Belmont County, Ohio*. H.C. Mead & Co., 1888, www.historicmapworks.com/Map/US/170524/Title+Page/Belmont+County+1888/Ohio/.

BROWN COUNTY

Lake, D. J. And Griffing, B. N. *Atlas of Brown Co., Ohio*. Lake, Griffing & Stevenson, 1876, www.historicmapworks.com/Atlas/US/7674/Brown+County+1876/.

Morrow, Josiah. *The History of Brown County, Ohio*. W. H. Beers & Co., 1883, books.google.com/books/about/The_History_of_Brown_County_Ohio.html?id=udUyAQAAMAAJ.

CARROLL COUNTY

Eberhart, G. A. *Illustrated Historical Atlas of Harrison County, Ohio*. H.H. Hardesty, 1874, www.historicmapworks.com/Map/US/20416/Title+Page/Carroll+County+1874/Ohio/.

Eckley, Harvey J. And Perry, William T. *History of Carroll And Harrison Counties, Ohio*. Vol 2. The Lewis Publishing Company, *1921,* books.google.com/books/about/History_of_Carroll_and_Harrison_Counties.html?id=WNoyAQAAMAAJ.

CLERMONT COUNTY

Hill, John. *Map of Clermont County, Ohio*. Williams & Dorr, 1857, www.loc.gov/resource/g4083c.la000607/.

Lake, D. J. *Atlas of Clermont County, Ohio*. C.O. Titus, 1870, www.historicmapworks.com/Atlas/US/11064/Clermont+County+1870/.

Lake, D. J. *Atlas of Clermont County, Ohio.* Lake & Gordon, 1891, www.historicmapworks.com/Atlas/Maps/US/11065/Clermont+County+1891/.

Rockey, J. L. *History of Clermont County, Ohio.* Louis H. Everts, 1880, babel.hathitrust.org/cgi/pt?id=yale.39002054234126;view=1up;seq=5.

Williams, Byron. *History of Clermont And Brown Counties, Ohio.* 2 vols. Hobart Publishing Company, 1913, books.google.com/books/about/History_of_Clermont_and_Brown_Counties_O.html?id=bdYyAQAAMAAJ.

CLINTON COUNTY

Brown, Albert J. *History of Clinton County, Ohio.* B. F. Bowen & Company, 1915, books.google.com/books/about/History_of_Clinton_County_Ohio.html?id=6dYyAQAAMAAJ

Durant, Pliny A. *History of Clinton County, Ohio.* W. H. Beers & Co., 1882, books.google.com/books/about/History_of_Clinton_County_Ohio.html?id=771Cp_3FMB0C

Lake, D. J. And Griffing, B.N. *An Illustrated Atlas of Clinton County, Ohio.* Lake, Griffing & Stevenson, 1876, www.historicmapworks.com/Atlas/US/7588/Clinton+County+1876/

DARKE COUNTY

Griffing, B. N. *Atlas of Darke County, Ohio.* Griffing, Gordon & Co., 1888, www.historicmapworks.com/Atlas/US/8294/Darke+County+1888/

Lake, D. J. and Griffing, B. N. *Atlas of Darke Co., Ohio.* Lake, Griffing & Stevenson, 1875, www.historicmapworks.com/Atlas/US/9826/Darke+County+1875/

The Lewis Publishing Company. *A Biographical History of Darke County, Ohio.* The Lewis Publishing Company, 1900, books.google.com/books/about/A_Biographical_History_of_Darke_County_O.html?id=vg3VAAAAMAAJ

Wilson, Frazer Ells. *History of Darke County, Ohio* 2 Vols. The Hobart Publishing Company, 1914, books.google.com/books/about/History_of_Darke_County_O.html?id=BToVAAAAYAAJ

Delaware County

Beers, F. W. *Atlas of Delaware Co., Ohio.* Beers, Ellis & Soule, 1866, www.historicmapworks.com/Atlas/US/11048/Delaware+County+1866/

Lytle, James R. *20th Century History of Delaware County, Ohio.* Biographical Publishing Company, 1908, archive.org/details/20thcenturyhisto01lytl

Perrin, Henry William. *History of Delaware County and Ohio.* O. L. Baskin & Co., 1880, books.google.com/books/about/History_of_Delaware_County_and_Ohio.html?id=wRAVAAAAYAAJ

Greene County

Broadstone, Michael A. *History of Greene County, Ohio.* 2 vols. B. F. Bowen & Company, 1918, books.google.com/books/about/History_of_Greene_County_Ohio.html?id=txIVAAAAYAAJ

Dills, R. S. *History of Greene County.* Odell & Mayer, 1881, archive.org/stream/oh-greene-1882-dills#page/n1/mode/2up

Everts, L. H. *Combination Atlas Map of Greene County, Ohio.* L. H. Everts & Co., 1874, www.historicmapworks.com/Atlas/US/9554/Greene+County+1874/

Rogerson, A. E. and Murphy E. J. *Map of Greene County, Ohio.* Anthony D. Byles, 1855, www.loc.gov/resource/g4083g.la000629/

Guernsey County

Cyrus P. B. Sarchet. *History of Guernsey County, Ohio.* B. F. Bowen & Company, 1911, books.google.com/booksid=79wyAQAAMAAJ&printsec=frontcover#v=onepage&q&f=false

Lake, D. J. *Atlas of Guernsey County, Ohio.* C. O. Titus, 1870, www.historicmapworks.com/Atlas/US/10407/Guernsey+County+1870/

Williams Dorr & Co. *Map of Guernsey County, Ohio.* Sarony & Co., 1855, www.loc.gov/resource/g4083g.la000630/

HAMILTON COUNTY

Emerson, William. D. *Map of Hamilton County, Ohio.* C. S. Williams & Son, 1847, https://www.loc.gov/resource/g4083h.la000632/

Harrison, R. H. *Titis' Atlas of Hamilton County, Ohio.* C. O. Titus, 1869, www.historicmapworks.com/Map/US/20654/Title+Page/Cincinnati+and+Hamilton+County+1869/Ohio/

Nelson, S.B. And Runk, J. M. *History of Cininnati And Hamilton County, Ohio.* S. B. Nelson & Co., 1894, books.google.com/books/about/History_of_Cincinnati_and_Hamilton_Count.html?id=a1QMAQAAMAAJ

HENRY COUNTY

Aldrich, Lewis Cass. *History of Henry and Fulton Counties, Ohio.* D. Mason & Co., 1888, books.google.com/books/about/History_of_Henry_and_Fulton_Counties_Ohi.html?id=8SJEAQAAMAAJ

H. H. Hardesty & Co. *Atlas of Henry County, Ohio.* H. H. Hardesty & Co., 1875, www.historicmapworks.com/Atlas/US/10845/Henry+County+1875/

HIGHLAND COUNTY

Klise, J. W. *The County of Highland.* Northwestern Historical Association, 1902, archive.org/stream/countyhighlanda00houggoog#page/n8/mode/2up

Lake, D. J. *Atlas of Highland County, Ohio.* C. O. Titus, 1871, www.historicmapworks.com/Atlas/US/11119/Highland+County+1871/

Lathrop, J. M. And Penny, H. C. *Atlas of Highland County, Ohio.* H. C. Mead & Co., 1887, www.historicmapworks.com/Atlas/US/9577/Highland+County+1887/

Scott, Daniel. *A History of The Early Settlement of Highland County, Ohio.* The Gazette Office, 1890, books.google.com/books/about/A_History_of_the_Early_Settlement_of_Hig.html?id=C04VAAAAYAAJ

Knox County

Caldwell, J. A. And Starr, J. W. *Atlas of Knox County, Ohio.* J. A. Caldwell & J. W. Starr, 1871, www.historicmapworks.com/Atlas/US/7590/Knox+County+1871/

Caldwell, J. A. *Atlas of Knox, County, Ohio.* E. R. Caldwell, 1896, www.historicmapworks.com/Map/US/175203/Title+Page/Knox+County+1896/Ohio/

Hill Jr., N. N. *History of Knox County, Ohio.* A. A. Graham & Co., 1881, books.google.com/books/about/History_of_Knox_County_Ohio.html?id=DBAtAAAAYAAJ

Lawrence County

Lake, D. J. *An Atlas of Lawrence County, Ohio.* D. J. Lake & Co., 1887, www.historicmapworks.com/Atlas.php?cat=Maps&c=US&a=32861

Willard, Eugene B., et al. *A Standard History of The Hanging Rock Iron Region of Ohio.* 2 vols. The Lewis Publishing Company, 1916, books.google.com/books/about/A_Standard_History_of_the_Hanging_Rock_I.html?id=gpkqAAAAYAAJ

Licking County

Beers, F. W. *Atlas of Licking Co., Ohio.* Beers, Soule & Co., 1866, www.historicmapworks.com/Atlas/US/11123/Licking+County+1866/

Hill Jr., N. N. *Hisotry Of Licking County, Ohio.* A. A. Graham & Co., 1881, books.google.com/books/about/History_of_Licking_County_O_Its_Past_and.html?id=_Xw8AAAAIAAJ

Perry County

Lake, D. J. *Atlas of Perry County, Ohio.* Titus, Simmons & Titus, 1875, www.historicmapworks.com/Atlas/US/9371/Perry+County+1875/

Shonk, Jim. *San Toy, Ohio.* J Shonk's Lost Ohio, 2012. www.jshonk.com/blogs/san-toy-ohio/

Preble County

Griffing, B. N. *Map of Preble County, Ohio.* Griffing, Gordon & Co., 1887, www.loc.gov/resource/g4083p.la000665/

Lake, D. J. *Atlas of Preble County, Ohio.* C. O. Titus, 1871, www.historicmapworks.com/Map/US/21605/Title+Page/Preble+County+1871/Ohio/

Lowry, R. E. *History of Preble County, Ohio.* B. F. Bowen, 1915, books.google.com/books/about/History_of_Preble_County_Ohio.html?id=SNoyAQAAMAAJ

Williams, H. Z. *History of Preble County, Ohio.* H. Z. Williams & Bro., 1881, books.google.com/books/about/History_of_Preble_County_Ohio.html?id=Oh9EAQAAMAAJ

PUTNAM COUNTY

Hardesty, H. H. *Historical Hand Atlas.* H. H. Hardesty & Co., 1880, www.historicmapworks.com/Atlas/US/7623/Putnam+County+1880/

Kinder, George. *History of Putnam County, Ohio.* B. F. Bowen & Company, Inc., 1915, archive.org/stream/cu31924028848699#page/n9/mode/2up

Seitz, D. W. And Talbot, O. C. *The Putnam County Atlas.* D. W. Seitz & O. C. Talbot, 1895, www.historicmapworks.com/Atlas/US/8574/Putnam+County+1895/

RICHLAND COUNTY

Baughman, Abraham J. *History of Richland County, Ohio.* 2 vols. The S. J. Clarke Publishing Co., 1908, books.google.com/books/about/History_of_Richland_County_Ohio_from_180.html?id=cBMVAAAAYAAJ

O'Byrne, P. *Map of Richland Co., Ohio.* Matthews & Taintor, 1856, www.loc.gov/resource/g4083r.la000668/

ROSS COUNTY

Bennett, Henry Holcomb. *The County of Ross.* Vol. 2. Selwyn A. Brant, 1902, books.google.com/books/about/The_County_of_Ross.html?id=1NwyAQAAMAAJ

Evans, Lyle S. *A Standard History of Ross County, Ohio.* 2 vols. The Lewis Publishing Company, 1917, books.google.com/books/about/A_Standard_History_of_Ross_County_Ohio.html?id=mToVAAAAYAAJ

Gould, Hueston T. *Illustrated Atlas of Ross County and Chillicothe, Ohio.* H. T. Gould & Co., 1875, www.historicmapworks.com/Atlas/US/9373/Ross+County+1875/

Walling, H. F. *Topographical Map of Ross County, Ohio.* H. F. Walling's Map Establishment, 1860, www.loc.gov/resource/g4083r.la000669/

Summit County

Doyle, William B. *Centennial History of Summit County, Ohio.* Biographical Publishing Company, 1908, books.google.com/books/about/Centennial_History_of_Summit_County_Ohio.html?id=tt0yAQAAMAAJ

Perrin, William Henry. *History of Summit County with An Outline Sketch of Ohio.* Baskin & Battey, Historical Publishers, 1881, books.google.com/books/about/History_of_Summit_County.html?id=XpM6AQAAIAAJ

Tackabury, George N. *Combination Atlas Map of Summit County, Ohio.* Tackabury, Mead, & Moffett, 1874, www.historicmapworks.com/Map/US/48004/Title+Page/Summit+County+1874/Ohio/

Union County

Mowry, A. S. *Atlas of Union County, Ohio.* Harrison, Sutton & Hare, 1877, www.historicmapworks.com/Map/US/21788/Title+Page/Union+County+1877/Ohio/

Durant, Pliny A. *The History of Union County, Ohio.* W. H. Beers & Co., 1883, archive.org/stream/historyofunionco00dura#page/n13/mode/2up

Vinton County

Lake, D. J. *Atlas of Vinton Co., Ohio.* Titus, Simmons, & Titus, 1876, www.historicmapworks.com/Atlas/US/9375/Vinton+County+1876/

Willard, Eugene B., et al. *A Standard History of The Hanging Rock Iron Region of Ohio.* 2 vols. The Lewis Publishing Company, 1916, books.google.com/books/about/A_Standard_History_of_the_Hanging_Rock_I.html?id=gpkqAAAAYAAJ

Warren County

Bone, Frank A. *Complete Atlas of Warren County, Ohio.* Frank A. Bone, 1891, www.historicmapworks.com/Map/US/174701/Title+Page/Warren+County+1891/Ohio/

Everts, L. H. *Combination Atlas Map of Warren County, Ohio.* L. H. Everts, 1875, www.historicmapworks.com/Map/US/1256383/Title+Page/Warren+County+1875/Ohio/

Beers, W. H. *The History of Warren County, Ohio.* W. H. Beers & Co., 1882, books.google.com/books/about/The_History_of_Warren_County_Ohio.html?id=nbLLGwAACAAJ

Websites with General Resources

Bridges – bridgehunter.com
Cemeteries – findagrave.com
Genealogy – familysearch.org
Ghost Legends – hauntedplaces.org
Iron Furnaces – oldindustry.org
Post Offices – postalhistory.com
Railroads – abandonedrails.com
Schools – oldohioschools.com
Train Stations – west2k.com